The Gospel

According to Viva Las Vegas

The Gospel

According to Viva Las Vegas
Best of the *Exotic* Years

by Viva Las Vegas

FACTORY GIRL PRESS

Cover & interior designers: Bo Björn Johnson, Rob Bonds
Author photo: Michael Hornburg

ISBN: 978-0-9912257-2-9

Unless otherwise noted, excerpts and articles are reproduced herein with special permission from *Exotic Magazine*.

Dedicated to Zen Guerrilla, Richard Meltzer, Frank Fallaice, and Huber's Spanish coffee

Contents

APOCRYPHA

Foreword

Viva Las Vegas and I are both tumor survivors—we both spent years working for Portland's sex industry and are still alive to tell of it.

Yeah, yeah, she had a lump removed from her breast and I had a knotty mass plucked from my skull—she recently noted the irony of how Mother Nature hit us each in the spots where we made our livings—but the real miracle here is that we both traveled through the slimy, unlit, carcinogenic bowels of P-Town's improbably large flesh trade and emerged from the other end without succumbing to the meth pipe or, even worse, the sort of self-deluded progressive rhetoric that strains comically to spray-paint a naked turd with gold.

It is to Viva's immense credit that in her writing, I never remember her using the term "sex-positive" nor gratuitously letting it slip that she made out with some chick in order to impress some guy at some bar. Or maybe she mentioned such things but I blocked them out, but that would only prove that I never associated her with the more stridently annoying ideological mushrooms who sprouted up in Portland whenever someone was taking off their clothes for cash.

Sure, Portland's a small city—smaller than it realizes—and I knew she was friends with, and generally agreed with, most of the town's self-appointed Sex Philosophers who tried to paint the industry as anything more meaningful than a cash transaction between unattractive men and attractive women, but Viva never seemed so fucking HOLY or JUDG-MENTAL about it. She was a bridge, almost a translator, between me and those sort of people.

I met her for the first time in the late '90s at a downtown Portland hipster coffee shop, introduced by my insane stripper girlfriend, the one with whom I was spending a yearlong boxing match that ultimately landed me in prison. Later that night after we'd left the coffee shop,

the insane stripper girlfriend said something catty about Viva. I can't remember the substance of her comment, but it seemed as if the root of her animus was because Viva was getting attention of some kind somewhere for something.

Ten days after I got out of Oregon State Penitentiary (the stripper girlfriend also wound up doing a few months in county jail for running over a bicyclist with her car), I landed a job with a local magazine—the name escapes me—catering to the Portland strip-club scene.

Viva was one of the magazine's columnists at the time. She told me that during the two-plus years I'd been caged, she'd been the only member of the local Sex Philosopher clique who stood up for me. It's understandable—unlike a lot of the others, Viva actually made a living as a stripper, which had given her an up-close-and-personal chance to see my insane stripper girlfriend acting insane.

Over the next eight years, we were both employed—fuck, I'm sorry, we were Independent Contractors—for that strip-club magazine in various editorial capacities. There were spates of mutual animosity between us at different times, which is why anyone who toiled alongside us in the beast's belly would probably think it's ironic I'm even writing this foreword.

Interestingly, the real geysers of hate spewed neither from me nor Viva, but from two additional girlfriends of mine. There's a video somewhere online of one girlfriend, a short Jewish one with breast implants, allegedly taking a swing on Viva in the back room at Dante's. Viva responded by throwing a drink at her. The other girlfriend was another stripper—actually, a sweet person except when it came to Viva—who wrote a column in a competing sex rag mentioning some things about Viva that many people would deem unmentionable.

Through all the 140-decibel drama, Viva retained the same demeanor she had when I met her in that coffee shop a dozen or more years ago—bright, chipper, and enthusiastic to a degree normally only found in adolescents. And the fact that she asked me to write this foreword shows she's truly more tolerant than almost anyone else in Portland. Viva *veni*, Viva *vidi*, Viva *vici*.

—Jim Goad
Atlanta, Georgia

Introduction

Welcome to the best of my writings for fabulous *Exotic Magazine,* now stripped of all strippers, escorts, and ads for criminal defense attorneys. (Sorry!)

There's been a skin rag devoted to the dozens of Portland nudie joints since their doors swung open. Strip clubs need to advertise, and oftentimes clothes-on zines don't want their money. If you're a smart cookie with an entrepreneurial bent, you can write your own check, as the saying goes.

Exotic was founded in 1993 by Frank Fallaice. It was his bright idea to mix Portland's favorite pastimes of sex and music, and to showcase them with decent writing and photography, something that the competition, *The T'n'A Times,* wasn't doing exactly. It might seem like nobody gives a rat's ass about editorial in magazines known primarily for their fleshy advertisements. But at *Exotic,* we did give a rat's ass. We gave at least several rats' asses.

Frank approached me to join *Exotic* as music editor in 1998. I was a stripper and in several bands, and he'd seen that I could write/speak my mind from my letter to the editor and subsequent debate on porn and feminism in the local weekly, the *Willamette Week.* He thought I'd be a perfect fit for the magazine. I wasn't so sure at first, but I have a policy of saying yes when strange twists of fate come my way, and was soon churning out my best approximation of rock criticism from *Exotic*'s offices in downtown Portland.

It was a fun gig. Without any oversight, I got to write and solicit whatever the fuck I wanted. This ran the gamut from goings-on in the downtown strip clubs to philosophical screeds about politics/sex/whatever to lots of fervent opinion pieces on rock 'n' roll. *Exotic* also got me backstage at a shitload of shows, where I pestered my heroes with stock questions about what they found sexy.

It was heaven, I tell you! Members of sort of obscure punk/rock bands like Gaunt, Zen Guerrilla, and Scared of Chaka became friends and family, sleeping on my floor, dedicating covers of "Viva Las Vegas" to me in the middle of their sets, or even backing me up for a song or two. I got to hang backstage with the Cramps, Ryan Adams, Mötley Crüe, Slayer, Peaches, and on and on and have awesome anecdotes about all of them. It was a dream job, in retrospect. But alas, sometimes the grass looks greener on the other side of the fence, even when you're ensconced in paradise.

So in March of 2001, I beat it to New York City. All the angst leading up to the move is documented, as is my passion for my new home. It was there that my roommate—a handsome, brilliant editor for Grove/Atlantic (Hi, Michael!)—suggested I compile my *Exotic* writings into a book. But soon 9/11 sent me scampering back to Portland.

Eight years later, I did finally publish a book: *Magic Gardens: The Memoirs of Viva Las Vegas* (2009, Dame Rocket Press). We quickly sold out of our first printing, and decided to dust off these old bits of arcana to celebrate the second printing.

Most people like to keep their mistakes to themselves. I evidently like to work them out in front of an audience of seventy-five thousand (the alleged circulation of *Exotic*, tho' I've always wondered what percentage of that stat includes mags that are read by several dozen people who find them on top of the toilet tank at a house party). Nowadays I s'pose they'd call it "blogging." But I'm old fashioned. I like trees to suffer for my mistakes.

Which begs the question: why murder more trees to reprint these decade-old musings of an angsty twenty-something? A very good question, indeed! Well, mostly cuz over the years, so many people have e-mailed or found me on Facebook or in a bar and said they loved such-and-such column. So we're publishing this book for Red, the hottest stripper ever, who still raves about "Short Skirt as Public Service," as well as for those guys who loved "Guitar 101" (and even sent thank-you notes from both coasts). It's for the anonymous attorney in Rhode Island who keeps asking when I'll get around to compiling this book, and for the homeless junkie musician who goes to his buddy's garage every morning to read back issues with his coffee and cigarette. Here y'are, folks—blood of trees, shed for you.

I gotta say that in rereading this material, I'm frequently mortified. It's a naïve Viva, trying to find her voice, trying to be braver than she is, trying to speak for all sex workers with some semblance of authority (hence the title "Gospel..."). But sometimes while rereading, I actually learn something. Naturally lots of the material seems dated now, but as someone said to me recently, "'dated' eventually becomes 'historical'." Ha! Wouldn't that be somethin'?

—Viva Las Vegas
Portland, Oregon

Thank You for Supporting the Arts
October 1998

Stripping is art. Strippers are artists. Of course not all stripping is art and not every stripper is an artist, but more often than not, the girl bent over in front of you at the rack, her eyes half-closed and her mouth half-open, has got a lot more goin' on than is immediately apparent. And chances are that if you, the customer, are at the rack, mouth dry, eyes bulging out of your head, transported away from your gritty Pornland workaday life, every atom of you focused on some abstract fantasy, your thoughts suspended in a sort of meditation on one of the most stimulating visceral experiences ever available to mankind—the female nude.... Indeed, chances are that you are experiencing art, like it or not.

It's a much-hallowed word: *ART.* Some people—mostly over-educated, under-experienced white people—take offense when I say, after every song, "Thank you for supporting the arts!!!" For them, I will write my two-thousand-page manifesto. For the open-minded, generous readers of *Exotic,* let me say simply that:

1. I am an artist who desperately needs and appreciates your support.
2. I believe that what happens in a strip bar is the best, most potent art the late-twentieth century has to offer.

In a recent lecture I gave to a PSU [Portland State University] philosophy class on this subject, I arrived at this definition of art: "Art is communication between an artist (doer) and an audience through an abstract form (the 'work of art')." Good art happens when the artist's

feel for form and nuance is presented in such a way that no matter how abstract the work, an emotional response not unlike that which the artist intended is elicited from the viewer. The best art does all the above and simultaneously reaches towards the spiritual core of existence. In other words, it's provocative.

Late-twentieth-century art has become so self-referential and warped by the tenets of post-modernism championed only in academia that much of it is nearly incomprehensible to the average late-twentieth-century viewer. Call me a commie, but I believe that art should communicate its message, its "reach towards the spiritual core of existence," to Everyman/Everywoman. To the best of my knowledge, nothing is as effective in this respect as a naked woman, dancing slowly to music under red lights so that every muscle is articulated and the curve of the spine becomes nothing short of a religious experience. If your hands start to shake or you break into a cold sweat, you can be sure it's art.

Women in art have often been confined to the role of the muse, their entrée into the world as artists limited by social conventions. However, women's bodies have been glorified, vilified, deconstructed, and reconstructed ad infinitum throughout art history. Sex is ubiquitous in art, the bind between the two as old as it is indestructible. Sex workers have also figured prominently, as many of the most famous paintings, writings, and sculptures are of prostitutes dressed up as ladies, dressed up as prostitutes, or simply not dressed at all. These works were undoubtedly contentious and often banned in their times; now they are worth millions.

At long last, women artists are being taken seriously in the art world. Keeping with history, much of the work they produce is concerned with issues of sex, gender, bodies, misogyny, and so forth. However, too much of their work is caught in the pervasive late-twentieth-century trend that dictates art is more about discourse and less about feeling. WHY is it that only women with expensive PhDs who produce works that refer to sex in very sterile, asexual, ironic, and even hostile ways get grants and endowments while your average bump-and-grind-ette gets only disrespect? I honestly believe that strippers are among society's most cutting-edge artists. And the price of admission to see some of the finest, most intensely personal art of our time is often just the cost of a beer and a few dollar bills.

The point, folks, is don't miss the Sex by Sex Workers Art Show this October at Fellini restaurant in Puddletown. See what we do outside of work, and then come see what we do at work.

And once again, THANK YOU FOR SUPPORTING THE ARTS.

WTO Shopping Trip
January 2000

It was one of the coolest shopping trips ever, those days the WTO [World Trade Organization] convened in Seattle. I love a man in uniform, and I really loved trying to convince those men, in my most convincing manner, that I just wanted to go to FAO Schwartz, so please oh please let me cross your cute little bad-boy formation.

"You know...FAO Schwarz, the toy store! We don't have one in Portland.... I came all the way up here to spend MONEY!"

And that's what did it. No sooner had I tongued the word than the Ninja Turtle softened up and rolled over, lifting the POLICE LINE DO NOT CROSS high for me to enter into their little cordoned-off corridor. Meanwhile, WTO delegates from around the world and local merchants struggled in vain to prove they had business in the area, as I examined plush toys and hundred-dollar Barbies.

It's the most magic of words: *money.* We in the "first" or "civilized" world live and die by it, and what we do, so shalt the rest of the world do. Right? Because we figured out the BEST way to live; the way to have the most THINGS. It's so obvious! So unassailable! Who are all these people in the streets, and why do they want to stop the WTO's profit-oriented machine?!?

A lot of the protesters did merely want money, too, like everybody else. Fair wages, fair working conditions, labor rights.... So why the WTO stood in their way is immediate cause for suspicion. It's a theory as old as economics. The more money the people have, the more they will spend, the better the economy. So why No, WTO? Aha! Because you

are the fat cats at the top who stand to profit obscenely from substandard labor rights! And you try to guilt us by saying that our insistence on fair labor laws is taking food out of the mouths of Third World populations. How? You underestimate our intelligence.

However, the main point made by the Violent Rioting of Black-Clad Anarchists (oh, and tens of thousands of others, too) was that there are other ways to measure wealth that are being ignored by the WTO, who, with their stranglehold on world legislation, heartily hope that we will forget about them. Wealth can be clean air, water, and food. Wealth can be cultural diversity and the importance of local governments and smaller communities.

It's a small world after all, and getting smaller daily. In one hundred years, ethnic differences will likely be so irrelevant as we all bow to one god, Capitalism, that anthropologists like me will be extinct. We will all merely be players in a global, TV-addicted, materialistic economy. The only relevant differences will be differences in wealth, and any and all warfare will be class warfare.

We the people are at a crucial point now. We made the WTO stop in their tracks for five days, a Herculean feat that must inspire us in the battles to come. The whole world is at stake. There's nothing to lose. Now that everybody's making resolutions and really intends to make good this year, please let's resolve to study our mistakes of the last two hundred years of American brand capitalism and tinker with the recipe before we shove it down the rest of the world's throats.

There are so many ways to measure wealth. I heartily believe that basing GDP on $$$ is coarse, obscene, and rips the humanity out of humans. Where Tanzania, the "second poorest nation on earth," is wealthy, America is horribly poor. In a fair version of global trade, we would import equal amounts of their amorphous wealth while exporting our cold, hard, and oh-so-quantifiable techno-gadgets. Our society would be as influenced by the philosophies and lifestyles of Hindu farmers as their society is by our televisions and the Spice Girls. And the foremost symbol of national wealth would be the number of people, young and old, who dance. Dance, dance, dance.

Bonjour
May 2000

Dearest Pornlanders,

Greetings from Barcelona, where I am up late in my little room in an ancient castle that, with its Catalonian tiles and threadbare bedding, reeks of local color. And piss. I am having a wonderfully sensual time in the Old World (it's crumbling), sucking down fruits of the sea, sweet Spanish wines, and the strongest sludge-like coffee any Midwesterner ever encountered. I have seen the angry albino gorilla and Antoni Gaudí's truly awe-inspiring modernisma architecture. Most importantly, I am a long ways from that monkey-brained U.S. Supreme Court, and so wish you were here!

Why does the Supreme Court think that naked ladies are threatening our vastly varied and certainly amorphous moral nation? Why does the highest law of the land insist, against all reason and statistical evidence, that nude women have inimical "secondary effects" on our violence-obsessed culture?

Here in Europe, sex is everywhere. It's in advertisements in the metro, snuggles up against fourteenth-century walls, flaunts itself on stages for tourist dollars, and, most plentifully, it happens in the world's finest art museums. Furthermore (surprise!), the Europeans don't seem morally compromised because of it.

In Paris, at the Rodin Museum, one walks into a room and is greeted immediately by the gaping cunt of *Iris, Messagère des Dieux*. Children gurgle past her, unharmed by her rawness. Goofy Asian men pose for snapshots with their hands on her when the guards' backs are turned.

The Louvre is overflowing with sexual imagery from every culture. Except ours. The only American painting I recall seeing was *Whistler's Mother*, which neatly summarizes America's puritanism with its gray, gloomy palette, stark setting, and stern subject.

Paris also boasts the morally-questionable cabaret—with its naked ladies and ribald parlance. But it's simply accepted as the huge tourist draw that it is. Camera-toting masses trek to Montmartre for two reasons: the lovely white church, Sacre-Coeur, and the rusty red Moulin

Rouge. Even retired Americans seem to think sex is okay so far from home, and pose for a photo or two beneath its red-lit awning.

In Barcelona's Picasso Museum, an entire floor is dedicated to the man's late-period etchings—two hundred virtually identical scribblings of cunt after cunt after cunt. Some hairy, some smooth. Some gaping, some tiny specks. And by that miracle of cubism, which deconstructs the 3-D figure and allows every naughty part to be shown at once, each slit is accompanied by a neat asshole, just like they all really are! And the good Americans were noticeably uncomfortable.

Oh, well. I wouldn't trade us for the world. I've spent years mulling over what is so special about the American conscience, which, for all its quirky hang-ups and desire to be clean and regulated, still has an easy familiarity with freedom that is not found in Europe. Trust me. If you live with Europeans (or watch their crappy TV) long enough, it becomes apparent. This ineffable sense of freedom resides deep in the American subconscious, stemming from our historical freedom to tell our government to FUCK OFF! And the more ridiculous that they, the government, get, the more emboldened we are to do so. *Land of the free, home of the brave* is like an equation. Less (sexually) free = more brave. Or, as in Europe, more (sexually) free = less brave. And America's obsession with violence fits neatly into this equation as well.

In our new legislative obsession, where sex *is* the greater sin, things can only get weirder. What of the pigeons, swans, and peacocks I saw copulating at the Paris Zoo? Or the simian cunnilingus? What about all the pregnant women walking around, shamelessly parading their sexual activity before God and man (many of them not even married)? Henceforth, I shall look at such women with horror, vehemently show my disgust, and spit, "You filthy rotten WHORE!!! You dirty slut! You've been having SEX, haven't you?!?" Well, America, how do you like me now?

L'Enfer, C'est les Autres
June 2000

The struggle for existence and hatred are the only things that unite people.
—Tolstoy, *Anna Karenina*

L'enfer, c'est les autres.
—Jean-Paul Sartre, *Huis Clas (No Exit)*

I'm back in Pornland, and not a moment too soon. I was starting to frighten myself. After being so lonely for over a month, I was talking to the ether, and what I had to say wasn't pretty. Mostly it was along the lines of "Fuck you, you goddamn idiot FUCK! Stop talking to me, looking at me, following me, grabbing at me! Keep your FILTHY French hands off me, you ASS!"

"In our country it is customary that when we see a beautiful woman we want to speak to her and get to know her and grope her and make her feel threatened and won't you make love to me even though I am a stinky hog enduring my middle age as a class-less, despicable slob?!?"

"Yeah, IDIOT FUCK? Well, in my country we sue and jail for such things. I am not flattered. Au revoir."

I don't know what it was, but my patience dried up totally. Maybe it was cuz I was getting sick, or because I had had such an unexpectedly warm welcome in Morocco that returning to the Eurofucks was a slap in the face. Who knows. But I was not in the mood to flirt with or be hunted by groady geezers every minute of every day. I even started composing a vehemently anti-sex column(!) in a gorgeous royal park in Sevilla. I was enthusiastically spewing vitriol across the page when I was interrupted by another cockless forty-something "I'm-a-professor-at-the-uni-what-is-your-name?"

"Viva. Vamos."

Then he tried to kiss me on the mouth.

Ugh, those Euros.

They do, however, put on some great cabaret. And contrary to feminist theory, the only time I encountered chivalrous, gentlemanly, respectful men on the Continent was at a titty bar in Paris.

I spent one beautiful May evening at the Crazy Horse, which, since 1951, has entertained Eartha Kitt, Alfred Hitchcock, Grace Jones, Martina Navratilova, Mick Jagger, Al Pacino, etc., etc. (celebrity visitors are listed on the wall. Check for Viva Las Vegas next time ya go!). The audience was fifty-fifty men and women, mostly Parisians, but plenty of tourists, too, including a horde of Japanese pleasure-seekers WITH their spouses!!! The forty-dollar cover included two fat drinks, and for sixty dollars more you got dinner. The joint was velvety and red, with very professional, very French waiters dressed to the nines. The crowd of two hundred was dressed quite formally, too. In front of me sat a mother, in her fur, and what appeared to be her son, maybe fourteen years old, in a tuxedo.

The show was fabulous. Although I missed the grit and personality I've become accustomed to in the States, fifteen girls, including Aria Crescendo, Crispy Suzette, Fuzzy Logic, Luna Lunatic, Pussy Duty-Free, Roxy Tornado, and Volga Moskovskaya, made up for it with brilliant costumes and routines perfectly designed for desire. All of 'em appeared in military "costume" (barely there) for the introduction, and stomped along in unison in combat boots so that their tits and asses jiggled for five titillating minutes. Yummy! Another highlight was a super-hip movie of the girls getting ready in the dressing room. I've always thought that titty bar dressing rooms are among the sexiest places on earth, and I was glad for the peek into the Crazy Horse's.

After the two-hour show, the polite and respectful men, and the two shots of whiskey, I was on cloud nine. I walked the two miles home to my hotel, along the Seine, with a full moon on the rise and the Eiffel Tower at my back. I even refrained from hissing, spitting, and swearing at unwanted advances for a few hours. But the next day it was Tolstoy and Sartre all over again.

But at least I tossed that anti-sex column, realizing that the open sexuality I championed last month wasn't responsible for the misbehavior of all the Eurodudes. For all my philosophies, those guys just can't be excused. In the words of bartender Patti at the Magic Gardens, "They're just jerk-faces."

And in the words of Judy Garland, "There's no place like home."

Mr. Rhythm Pays a Visit: Doing the Big Nasty (Interview) with Andre Williams

Co-written with Jon Sarre

August 1998

Sitting outside of Portland's fabulous Satyricon, scanning the bus mall for sign of an Econoline van with California plates is not exactly the way I like to spend my Friday nights. Granted, killing time with *Exotic* ingénue Viva Las Vegas made for far better company than the local gaggle of stumbling drunks that usually wanna share their conversations with God, but the nearly two-hour wait had exhausted Ms. Las Vegas's infamously puny reservoir of patience. We were beginning to think that maybe Andre Williams, legendary pal of Ike Turner and Berry Gordy, blues badass, Garage&B pioneer and the man responsible for the best record of 1998, *Silky* (In the Red Records), may just be stiffing us.

Repeated glances at our wrists (which eventually made us both resolve to buy watches) only prolonged the wait. Hope gradually turned to despair. The other bands on the bill, the Screamin' Furys and the Subsonics, had shown up and loaded in. The show was beginning to get under way. Just when things looked worst, we spotted a white van speeding down the bus mall; it was Mr. Rhythm himself, in the company of his superfuckinggreat backing band, the Countdowns! They drove right by the club, but came back a couple minutes later; they were kinda lost, as it turned out.

So how did the sixty-one-year-old Andre Williams look after a nine-hour drive up from San Francisco? Suave, dapper, and immaculately dressed in a red silk suit, damn sure putting to rest that "Who's the Mack" question. Viva and I buttonholed him and Brian from the Countdowns as fast as that etiquette shit would allow and steered 'em over to a vacant table.

VIVA: We know you just got here, thanks for doin' this. Jesus Christ, this is great!

JON: Yeah, we don't wanna hassle you…

ANDRE: You know, this is a new area and I've been dyin'…like, South Dakota, North Dakota, Oregon are the only three states that I've never been in all my life.

VIVA: What about that song…?

JON: So you really weren't the "Only Black Man in South Dakota"?

ANDRE: I did that cuz I wanna go to South Dakota so bad, so I thought I'd write that… Okay, y'all know Brian Waters… He's from the Countdowns, so we are like a team.

JON: You guys playin' all the shows?

ANDRE: Yeah, for sure.

BRIAN: Yeah…

ANDRE: As of August 1, it's gonna be a package… We're goin' to Europe. It's been overwhelmin' [so far]. I'm just waitin' to wake up and see that this is all a dream.

JON: So how'd ya hook up with Mick and Dan [from the Gories, who backed up Williams on *Silky*]?

ANDRE: Well, what happened was, I did an album on St. George Records, *Greasy*, and *Greasy* was in New York… It was a lot of old blues stuff… I asked Bill of Norton Records, and I said, "Bill, I wanna come to New York," you know, I said, "Get me a shot at New York." So he set me up to go to Chicago Blues in New York and Maxwell's in Hoboken and when I got to Hoboken, I met the Demolition Doll Rods, Margaret and Dan… So when I met them, they introduced themselves to me and told me they were from Ferndale, Michigan. Well, I had put in some, like twelve, thirteen years in Detroit, so I automatically bonded with 'em and after the gig, I flew to Detroit. And Margaret said, "There's a guy in L.A. you oughtta meet, Larry [Hardy of In the Red Records], she said, "Andre, you've got a cult following that's unbelievable." I say, "What the fuck is a cult following?"

BRIAN: You said you thought it might be the Klan…

ANDRE: Yeah [laughing] the Ku Klux Klan! So I call Larry and Larry was just… A-1 to go… Then I went to Detroit, and I met Mick and I already had my notebook fulla songs… You know, I had my ideas of different kinda crazy shit I wanted to do, so I asked Larry… I said, "How real can I get with your label?" He said, "Bring it on!" I said, "You know you're right up my alley, cuz I'm gonna kick ass for real!" cuz the rest of 'em say "Ooooh, I don't know, Andre…ooowwww!"

VIVA: Songs about fucking aren't allowed on the radio…

BRIAN: The guy from Norton was complaining that he couldn't get Andre to not swear into the microphone when he was doing his vocal tracks…

Jon: What's with Norton, cuz they put out those Charlie Feathers records... Hasil Adkins...?"

Andre: What it really is, is that...when ya mention the word "Andre," you're lookin' for an old dilapidated motherfucker gettin' off the turnip truck in a wheelchair.

Jon: Like one of those Fat Possum things.

Andre: Yeah, comin' to the end.

Viva: I want a guy in a red silk suit.

Andre: Well, you got it! Cuz that's the way we play it! You know, so anyway, we did the album with Larry. Larry put the album out... I still don't believe it, what's gettin' ready to happen... I'm doin' the blues circuit, I'm doin' fairly well...and Larry kept sayin' "Get ready, you're comin' out to California"... So then Brian calls me... "Andre, you know, we're gonna do this, we've been workin' on your stuff, so it's gonna be fine..."

Viva: How'd the kids respond down in Cali?

Andre: Woooh!!!

Viva: Yeah!

Brian: I've never seen a club so packed at 8:45 PM.

Andre: We've just been rapin' them! I'm serious, I've never been so satisfied with my show as I am at this point... The people, the band, the money, the owners, everybody is just right in sync with Andre Williams... gettin' sweaty and then they treat me great and we work... We're on stage two hours, you know; we don't take the money and run...

Viva: The songs you've got, when've you been writing these songs... how far back?

Andre: Four of those songs I wrote ten years ago.

Viva: Which ones?

Andre: "Let Me Put It In," cuz they said it couldn't get played, so I put it on the back burner... and "Bonin'." I had that for a long time, so now I'm just pumpin' 'em out. Brian and me have been writin'...

Brian: We got a new song called "Slam That Thing"...

Andre: That's goin' on my next album. We're gonna open the show with that...

Viva: We got your record...and I've been stripping to it. [Brian and Andre clap] The guys love it!

Andre: Here's how I feel, it's the most honest record this year... I look at you and I look at you and I get to talkin' 'bout the dick and the

pussy, and you know what it is...so we ain't talkin' 'bout nothin' new... let's get real here! Mormons do it too, or there wouldn't be no little baby Mormons! Damn right! So the whole thing is just tell the truth... BAM! Right across the board. I had to start doin' rhythm and blues if I wanted to eat...but I never claimed to be a singer...

Viva: What do you claim to be?

Andre: Well, I'm just an entertainer... Once you see the show to-night...and I'm not braggin', I'm not puttin' you on no ego trip here... Eighteen months from now, we will play downtown...cuz these kids [the Countdowns] are workin'... I can't say you're gonna love me to death, but I can say you're not gonna get disappointed...in the time that we are gonna put in...and plus I'm a freak for color, so we dress...we dress well... We set a standard, and that's the way we live...

Viva: What about Viagra, you gonna dip into that?

Andre: I don't need it...

Viva: I heard if you don't got a problem, you got less of a problem...

Andre: I think Viagra's good for guys who snort cocaine and can't get hard... I don't need it, baby, especially with our schedule, we ain't gettin' none already... I mean these guys are gonna be so happy when they head home, when they see their girls and shit...

Viva: So what do you think of girls in rock?

Andre: What the world needs is a female Andre Williams. The market is so ready...

Viva: A female blues singer!

Andre: Yeah, I mean, she would kick Madonna in the ass in one year! If you could get a raw, female, blonde that could rip that shit down... I'm talkin' 'bout a megastar... I'm talkin' 'bout where they're gonna be around both corners in both places at the Silverdome, y'understand? Man, look, the market is sooo ready for that lady...whoever she is...

Jon: Sorta like a female Jon Spencer...

Andre: There you go! You hit it on the head. If she arrives, she's gonna be sooo rich! I was amazed at [the women] with their credit cards who were just dyin' to see Andre Williams... They coulda done anything else, they coulda flown to Monte Carlo...

Viva: You know, it's honesty! Honesty's at such a premium these days...

Andre: Everyone's dreamin', namedroppin', all that bullshit...

Fuck that! I am goin' to tell the truth all the way to jail! This whole
life thing, it hasn't been easy... I gave up a lot of booty, but then I got a
lot of booty too... Then I come to find out that I got one of the fattest
publisher's catalogues of any black man in the arts...

JON: What song did the Cramps do of yours?

ANDRE: "Jailbait."

JON: Did you know that, when they did it?

ANDRE: No... First time I met Lux [Interior, Cramps singer] was
two weeks ago... He came to my show... They're gonna be on a compi-
lation with me.

JON: They must be fans from way back...

ANDRE: Way, waaay back, see, when you're real, it ain't hard to get
along with people... The whole thing is about building... I'm available
for whatever... I'm prepared for whatever comes along. If you treat me
like you love me, I'll treat you like I love you. The whole thing is about
this: you're gonna be real and you're gonna have fun until you become
unreal and then you're gonna have problems... Let's call a spade a spade,
call a club a club, and let's get on with life... It's so simple. We make
it complicated. We complicate shit all up, puttin' this in play and that
in play... Don't do nothin' yesterday and you ain't got problems today...

JON: I think I was gonna ask you, "What is the Andre Williams
philosophy of life?" I think you just answered that.

ANDRE: My philosophy on life? Stay in the studio, sooner or later
one of those songs is gonna come together...okay?

JON: Okay, let's go see the Subsonics.

With that, the interview ended. Jon and I caught the last half of a
scorching set by the Subsonics, then watched in awe as Andre strutted
his stuff, backed by the fabulous Countdowns, who were dressed for
the occasion in red choir robes. Andre did not one but two costume
changes—surely a first for the world-famous Satyricon. Such raw, hon-
est music about fucking has not graced Portland in ages, I'll wager...
There was not a dry panty in the house, and the generally unexcitable
Satyricon crowd was talkin' 'bout Andre for days after the show!!! But
I bet I'm the only gal who got to kiss him that night. Three times!
Plus I got his home phone number for a promised tour of NYC by Mr.
Rhythm himself. Eat yer hearts out, babes.

Short Skirt as Public Service
August 2000

Alright, Pornland! It's August! The only month around here that you really can count on being nice and steamy. Finally time to pull out every short skirt, tiny halter top, and pair of non-sensible, open-toed, high-heeled sandals you gals have been hoarding.

It's too bad we chicas can't make tips whilst walkin' down the street in our barely-theres, cuz we sure are taking a pay cut at the downtown clubs, which are all but deserted while the sun's out and long tanned legs parade by in microminis—GRATIS.

So, sans the singles I'm accustomed to accumulating for baring flesh, my reveries have been centered around the important charitable work we women do, merely by beautifying ourselves and walking around amongst the masses. It really is a public service, a morale booster, as much an affirmation of life as a garden of rose bushes or a statue of Abe Lincoln.

Being attractively turned out when the heat is on is not as simple as it appears, either. Boys, with their more limited dress code, might never comprehend the generous service the ladies perform in the summer. It may even appear to them that we are merely gluttonous in our shopping habits and unbearably impractical and whiny when our little stiletto mules cut into our tender foot flesh after only two city blocks. But you gotta love all the pretty birds mincing around in tiny skirts and oh-so-NOT-Portland non-chunky heels.

My litany of complaints inspired by my summer wardrobe starts with the most obvious. Lasting from fifteen to twenty warmish days, Portland's summer is hardly long enough to wear every pair of cute summer shoes I collect over the course of a year. I find myself changing outfits three or four times a day, just so I can be sure that every outfit gets its time in the sun. It's a miracle I leave the house at all. If I actually have to leave the neighborhood, I need to wear shoes or boots made for walking, or I need to drive the half-mile downtown and deal with parking. And driving a stick with six-inch platform heels is tricky (and illegal in Japan). Guys, are you appreciating this? Anyway, it's a pretty tortuous process, really, and I feel some kind of remuneration might be fair.

There is an entire category of complaints reserved for the short skirt. For instance, the day may appear sunny and hot on your porch, but once you're downtown, you may notice for the first time the wind tunnel effect created by the rows of tall buildings. However, I do LUV to see ladies walking around holding their purses, cell phones, and myriad parcels all in one hand while nervously clutching their flyaway skirt to their thighs with the other. It didn't feel that short at home, did it?!? And best of all, I like looking for glimpses of panties.

Also on the "curse this skirt" list: if it's short enough, sitting down gracefully presents a problem. Twice this summer I've found myself hurrying along a conversation or meeting, all the while perched precariously on the very very edge of my seat so as not to have the chair's pattern follow me around the rest of the day in seemingly permanent pink welts. And you really start to notice the age and quality of certain movie theaters when parts of you that are normally covered come cheek-to-cheek with upholstery that's seen a lot of popcorn and Pepsi.

Finally, most groovy summer wear has no pockets. You have to take a purse. Or a boyfriend. And I hate carrying a purse! But I do it. And get that sorta sanctimonious feeling, like, "How generous of me, to be inconveniencing myself just to decorate Portland's Clean and Safe streets; what a valuable function I am performing in society." Heads turn, guys holler and whistle, and I may wish I were wearing a trench coat atop my white miniskirt and crocheted bikini top and maybe some speedier kicks… But then I think, "What would Charlie's Angels do?"

Here's lookin' at you, ladies.

PS: Always, *always* reapply lipstick in public. It is so super hot when you do that!

Spread It and Smile
September 2000

Most recently in my unending quest to justify the sex industry to ignorant nonbelievers, I've been thinking a lot about objectification. To many of our detractors, this is the cardinal sin of the sex industry: the whittling away of Woman to one attribute, her sexuality. Not even her sexuality, which is indeed a many-headed monster, complex and stinkingly human, but her pussy. They're just desperate to frame us with some crime against humanity, thus "objectification."

According to this charge, when men see a naked woman, ALL they see is her nakedness. However, this totally flies in the face of the male psyche, with its incredible aptitude for fantasy. That, in a nutshell, is why porn is so much more appealing to guys. They see a two dimensional pussy and then dream up all the qualities and other appendages of the woman it belongs to. Given the same Christian Dior ad ripped from *Vogue*—you know, those ads with two long-limbed girls all sweaty and scantily clad and apparently hot over each other's monogrammed boots and purses—most women will see the boots and purses and fantasize about taking them home, but most guys will see two sweaty babes and fantasize about taking *them* home. Which is worse? Which is more demeaning to the human in the photo? Which is more *objectifying*?

So, why do men and women go to strip clubs? Often it is for entertainment: visual stimulation that is personal, intimate, and pretty punk rock. They get spontaneity, grace, joy, and skill—everything you can find at the ballet, but in a much smaller venue, on a more intimate, real, and correspondingly unique scale. And there's a lot more to see than t 'n' a. Dancers talk, they're in control, and that's what's sexy about them.

I've always felt that there are two schools of customers: guys who go for eye contact and guys who don't. The latter has a purely sensualist's eye and sees a clad stripper and wants her unclad; his eyes follow your hips at all times, and he cocks his head unnaturally, signaling what he wants to see: pussy, no more. The rest is wrapping. For some reason, this type has always unsettled me somewhat. Perhaps I hear my foes' echoes of "objectification" ringing true?

However, I know lotsa girls who hate eye contact with customers. "Don't look at my eyes, look at my *pussy!*" It makes the job a hell of a lot easier—and not as totally nude—when you shield your soul from the prying eyes of strangers. Just spread it and smile. Or don't smile! Just spread it. Easy as pie.

But I firmly believe there are two reasons guys come in: for a little bit of fantasy and a little bit of soul. A little bit of lies and a little bit of truth. Probably the second most-asked question at a titty bar, following close on the tail of "What's your name?" is "No, what's your *real* name?" Who cares! You saw my pussy, right? But they always want more. They want to know you, the *real* you.

Objectification? Maybe initially, but give 'em a few sets and most come around.

Lord knows there are plenty of folks out there—men and women—who admire a fine body and wanna take it home and touch it all over, no more! But even then, our hearts get the best of us and we want more. It's the stuff sitcoms are made of, and what separates us from higher animals—most of them keep their friendships and their fucking separate. But we can't separate our hearts from our genitals! It's rather endearing, really, and makes true "objectification" in the sex industry impossible.

Now *Vogue*, that's another story.

Buffin' Boots
October 2000

My last four boot shines are a travelogue of my serial wanderlust. Back in April, I got a gorgeous shine from a hundred-year-old geezer on Las Ramblas in Barcelona. He seemed none too comfortable about shining a lady's knee-high boots (naturally necessitating a skirt).

A week later, after several days of rain and ankle-deep mud, I sought out a little boy in Fez who did an exhilaratingly virile job. His scrawny arms belied his strength; I felt like I was getting a long-deserved leg massage (and a little like Mrs. Robinson). Some schmuck more my age

paid the kid his two dirhams (twenty cents) and invited me into his store. I tipped the boy another five, then browsed obligingly. Such hospitality.

Although the kid's technique was good, his supply box left a bit to be desired. I imagined he'd not been in the business very long, and was obviously trying to skimp a bit on the polish. A week later I was more then ready for yet another boot shine, this time in Marrakech. It was evening and I'd just cruised the Djemaa el-Fna, the infamous square where anything and everything goes: snake charming, anatomy lessons, ritualistic healing, Jimmy Page, sheep brains, fish and chips, and orange juice, orange juice, orange juice. I sensed I was being followed and was overjoyed to see two toothless men sitting on a stoop, with their little wooden crates and tins of polish laid out for passers-by. And they, as it turns out, were overjoyed to see me. I got the feeling they'd been engaging either in ritualistic healing or Jack Daniels. My suspicions were confirmed when they asked me straight away if I'd pay them in wine. I laughed and offered them the rest of the Mexican rum I just happened to be carrying in my purse. They recoiled in horror. Although many Moroccan men like to indulge in beer and wine nightly, they steer clear of anything stronger. For the best, I guess. The men chattered and laughed as we conversed in totally broke-down French and bits of Arabic I'd learned. What the shine lacked in technical merit was well made up for by the outta-sight theater.

My boots estivated over the summer months, and made their fall debut during those chilly days in early September, their dusty Moroccan shine still apparent. The situation was soon ameliorated at the airport in Manchester, New Hampshire. I flew back East for a friend's wedding, and on the way home was informed that my flight was overbooked. Would I like to wait three hours, fly first-class, and receive a five-hundred-dollar travel voucher? Hell yes, I would. I'd seen that Mr. Shine guy in the lobby. He was a strapping young buck, well-muscled and looking pretty damn eager for 5 AM. No sooner had I signed for my voucher than I was seated in front of him, watching intently as he outshone anyone on either of the last two continents. Turned out he used to be a fireman. The three-hour wait was well worth it already, and I hadn't even begun to dream of how I'd spend the five hundred bucks in travel, or which countries my made-for-walkin' boots would shine in next.

Eulogy
December 2000

Hurtling towards the obvious, eh moonlight lady? You can try to prevent it, forget about it, derail it…but we are all indeed hurtling towards the obvious. Our paths are set, and no amount of mind shrinkage, drug drinking, or soul fucking is gonna change it. I'm hurtling towards luminous, murderous mediocrity. And you? Here's derailing it: jump off a bridge, or an eight-story parking ramp for that matter. Take charge.

This year the obvious came and stole lots of people I knew and loved. Before they left, they seemed just one of us, the usual mortal slime. But once they were plucked from the now, they began to take on this ghastly destined-to-die…. They were NOT like us. They were too beautiful, too kind, too sensitive. Their hearts literally too big, too easily wounded.

I depend upon people to come in and fuck my shit up. Drugs are too predictable. People aren't. The theologian Martin Buber said, "All real living is meeting." I couldn't agree more. I meet a LOT of people. To undermine the scourge of the obvious, I throw myself into the strangest circumstances, where I feast on the humans I meet. Sometimes I even love them, but I try not to. TOO GODDAMN DANGEROUS. But the sneaky bastards can get under your skin!!!

I am an anthropologist by schooling and by disposition. We are an intentionally dispossessed lot, always observing communities, families, cultures, and yearning to belong. But we don't allow ourselves to fit in, because that undermines our dispassionate observational skills, our compulsive ideology of FREEDOM.

But freedom's just another word for nothing left to lose. Down at the Magic Gardens, I managed to get entangled in spite of myself. Who knew that in the bowels of a Chinatown in the gold-rush new-West was a little community where I inexplicably belonged? For four years now I've been snaking around there, paying homage to nicotine and Jim Beam. Lots of people pass through the joint, some stay forever. But man it's quite a spoonful who started out year 2000 with us and just ain't around no more.

In the spring, L.A. Kid and his Girl did a nouveau Romeo and Juliet à la stupid fucking horse. Same pony ride left a great bass player

and a beautiful punk rock girl cold on the floor. Michael and Alexa were killed in the fall by their own beautiful hearts. And last month Christian, our beloved bartender and everyone's best friend, died choking on those country-fried songs he loved, worshipped, and was—with his boots on.

If only we could have this year's Christmas bash with the ghost of Christmas past! But we're too busy, hurtling towards the obvious.

Here in front of me, standing on the corner, is the ghost of Christmas now. A Mexican in tight jeans, gorgeous alligator boots, a long black mane, and wraparound sunglasses, chewing gum cockily as he walks up Burnside into the sunset. Chewing gum and strutting in the face of certain ruin. Draped in vanity and soul, walking upright in spite of the weight of the world, which is something like thirty-two feet per second per second, which is really very, very, heavy when you think about it. He's hurtling towards the obvious, and doesn't even seem to care! The BALLS.

Here's to you, ballsy pimp-dressin' dude. In the New Year I wanna follow you into the sunset. You've got it down. I'll not laugh in the face of death necessarily, but clad myself in gorgeous armor, the trappings of life. Every moment is so precious that it can be overwhelming. So I'll try not to think on it, but celebrate in minutiae: codes of dress, a swagger and a cowboy hat. Four-inch heels to the grocery store. Why the hell not?

When people die, they haunt the familiar and occupy huge psychic spaces with their ghosts. It makes the world around you look a little less real.

But I'll tell you what's real: pink snakeskin high-heeled sandals that make matching little pink puffy scars in your feet. Somebody bought me some in the dead of winter. He's inscrutable. They aren't. They are real.

Here's to 2001 and gum-chewing (getting hitched, having babies) in the face of doom. And, if I could ask for one thing, let the black angel's death song play on away from my little life awhile. I promise I'll be good.

Women in Strip Clubs
February 2001

So, a friend of a friend came into the bar the other night and said she thought that I should do a column about women who visit titty bars. Just the idea twisted my mouth into a grimace of annoyance, though I pretended I felt otherwise. But whenever your face does something in spite of yourself, there's something there, a little bit o' thorniness to be examined. So here ya go, ya gorgeous Clara Bow girl, who stared at me with evident excitement and supported the arts most sufficiently and respectfully... Aw, honey, if only they could all be like you!

Women are fascinating psych-maps, wild cards at all times, and sensitive to the subtlest vibrations. I can't understand 'em...try to avoid 'em...don't really trust 'em. "Snakes in the grass," Grandma told Ma told me. Snakes in the grass. Infinitely wise, infinitely cunning, infinitely slippery and unpredictable. I don't even trust myself.

Of course some women—the luminous ones, well on their way to beatific self-actualization—sit at the rack side by side with the boys. They tip well, are sufficiently entertained, appreciative, and even tacitly approving. They are delightful. Gorgeous. Fascinating. Possibly still snakes, but I am easily beguiled...

But for those handful of lovelies, how many crass, khaki-clad, naysaying wenches must we endure? It's obvious they feel threatened. They've entered the temple of doom and must (a) be obnoxiously naughty and distracting, or (b) be rude and derisive. Girls will often snicker and loudly whisper how fat/thin you are, how large/small your breasts are, etc. And the gals who are out with their guys in the naked city, they gotta show that they are as naughty/desirable/into exhibitionism as the working girl. This type makes out with strangers at the rack, sits on laps, and keeps her hands and tongue awfully busy. It never works to call these girls on their improprieties. I've had it escalate into some pretty ugly stuff.

"Uh, excuse me? You're being rude. Could you at least whisper so I can't hear you?"

"YOU'RE being rude!!! I can't believe you just said that to ME!!! I'm gonna get you fired!"

One time I hit a girl.

On the other hand, it's probably good that these ladies are taking the first step in confronting their hang-ups by staring us beasts in the eyes. There's a multitude of things to be learned in a strip club. One that's perhaps most important for women is that titty bars are not all they're cracked up to be. The women are not always strung-out junkies who whore about the bar, trying to steal people's husbands after giving a degrading gynecological show for fat furry oafs. I myself was shocked to learn that strip bars, of all places, are filled with the neo-proverbial thousand points of light. And, if you watch the show respectfully, you just might learn something about yourself. The gal who commissioned this piece said she'd learned a lot about her own sexuality!!! Mahvelous! I wanted to pick her pretty brain on that one, but she vanished into the sultry Old Town night. So here's your column, doll. Hopefully you'll be in again soon so we can compare notes on what we've really learned. Here's a few bits that knocked my socks off (and everything else):

- Women come in all shapes and sizes. And people find this variety attractive and wonderful. Outrageous!!!
- A very large number of men, when faced with an all-nude girl, prefer to look her in the eyes and get turned on thusly. And so do I.
- Naked girls are open about a lot more than their bodies. Frequently they'll let you into their lives without prejudice or suspicion and can quickly become your best friends.

Oh, and one final admonition for the guys and gals... Giving a stripper a dollar in your mouth is SO unhygienic, and not at all sexy! Perhaps it pleases the boys, but you and I are in danger of contracting the whole alphabet of hepatitises! Think about it.

Happy VD.

—V

Bye, Portland
March 2001

The devil is the spirit of gravity.
He who is not a bird should not build his nest over abysses.
—Nietzsche, *Thus Spoke Zarathustra*

Too true, too true. The devil is the spirit of gravity. I've been here nearly five years. FIVE YEARS. A personal record. Often I've felt that it was gravity keeping me here. The DEVIL. But I am a bird. I can fly. Ain't been stretchin' my wings much lately, tho' (you noticed?). So, before they atrophy and I die in a lonely bridge-jump, I'm burnin' down the house. Cuz the obvious extrapolation from the above quotes is how do you know if you're a bird if you don't challenge the spirit of gravity? If you don't live over an abyss?

So, Portland, I gotta go, though it breaks my heart to say it. I become too complacent if I'm in one place for too long. In my life I've mastered this trick. I call it *the phoenix*. Once I've ridden roughshod over all the hearts and hillocks I wanna, then I've no choice but to set it all aflame. Burn the bridges, burst the bubbles. And like the mythical phoenix, rise from the ashes.

I guess my destination is New York town. I got a bass player out there. And a million friends. My only goal is to make y'all proud.

'Course I do owe you a lot, Portland. I mean, when I arrived back in '96, I didn't know how to drink at a bar, didn't know how to carry a purse, had never seen eyeliner or owned naughty shoes, had never tasted a manhattan or let someone buy me a drink. I've totally fallen in love with so much of you, so many of you. Hell, Old Town is the fifth chamber of my heart.

Right now I'm suckin' down a Marlboro Light and chit-chattin' with an alcoholic elder at Huber's ("#1 Kahlua sales in Oregon"), where I've conquered the demon writer's block many times with one or two Spanish coffees. And let y'all see me ALL-nude. Strikes me as funny, how stripping can be so intimate yet so superficial. I've bared a hell of a lot more in these little columns. Viva's cocky "WHAT I KNOW,"

"WHAT I WANT," and "I SPEAK THE TRUTH." And ya know, I've been sifting through the past three years of musings, and I must say my opinions have not changed:

1. Rock 'n' roll should make your panties wet.
2. Zen Guerrilla rocks the MOST.
3. Stripping is art.

This older gal down the bar from me is butting into my column, all lubed-up with vodka sodas, tipping quarters, and imperiously demanding of the bartender: "Gavin! A match! I've read everything on this box (Marlboro Lights), Gavin, and it says 'Made in the U.S.A.'"

"Richmond, Virginia."

"They have the best horses there. I read somewhere that that's where Queen Elizabeth vacations to buy horses."

Anyway, I'd like to further investigate the above truths in the next few years. And it looks like I'll be reporting back to y'all from the front, as *Exotic* has asked me to keep up the good work, albeit from the other coast. I think maybe I'll change the title, though, from "the Gospel" to "Sex in the City." Oh, YEAH.

"Gavin! How do you spell eenie meenie minie moe?"

"I try not to very often. I'd rather spell supercalifragilisticexpialido-cious, ya know?"

"Well, you're educated."

This is a great town. Don't think I don't think so. It's just...the abyss...the abyss is calling me.

And once more with feeling, ZEN GUERRILLA, motherfuckers!!!

A Whore Just Like the Rest:
Rock Critic Richard Meltzer Repeats Himself
March 2001

Offensive, repellent, repulsive, and totally without redeeming social anything.
—Liza Williams, former head o' publicity for Capitol Records,
 on Meltzer's scribblings

Well, seein' as how I'm rarin' to get the hell outta this burg, I gotta tie
up/cut off the loose ends, right? And seein' as how there are no more
cowboys out here in the storied West, a gal's gotta invent 'em, right?
But there's still tequila, and there's still RICHARD MELTZER. I've
had Meltzer in my sights (for an interview, jackass) for ever-so-long, but
was waiting 'til I finished his latest book, *A Whore Just Like the Rest*, ya
know? But Meltzer can be a, er, challenging read. Witness this CCR
review from *Creem*, circa 1971:

You you you kinda kinda kinda get get get the the the impression pression pres-
sion that that that Creedence Creedence Creedence Clearwater water water
keeps keeps keeps doing doing doing the the the same same....

You get the idea. But then, as he says in the intro, "Rock repeats
itself more than any of us ever could." And HE SHOULD KNOW!!!
He was there since the beginning!!! And, to those of us who still CARE
about the genre, he's a god of sorts. Cuz, see, he wrote the book on rock
criticism, back when it mattered, back before the rules got invented.
Back when he could make up fake interviews with Andy Warhol or
title reviews "Hot Tuna is Hot Fuckin' Shit" and "What a Goddamn
Great Second Cream Album." Back when—get this!—rock criticism
was regarded as an art form in itself!!! Perhaps even equivalent to plain
ol' rocking!!! Jimi Hendrix read the first U.S. review of his shit—by
Meltzer—and shook the guy's hand and said, "You were stoned when
you wrote that, right?" AND IT DON'T GET NO BETTER THAN
THAT. Not if you live in Viva's world...
 Of course, calling a spade a spade has never been too popular, and

Meltzer probably got kicked out of more magazines, parties, and concerts than he got invited to (and by the likes of *Rolling Stone* and Bill Graham, no less). A goddamn COWBOY.

Unbelievably, a fishwrapper still prints his heat-seaking missives. The *San Diego Chronicle* seems to know what it's got, and once even let Meltzer weigh in on a Pat Benatar show (11/28/97) thusly:

ROCK DEATHS THIS WEEK: Art Garfunkel (stroke)… Van Morrison (smallpox)… Mark Mothersbaugh (crushed by falling safe)… Belinda Carlisle (contract killing)… Richard Hell (natural causes)… Cat Stevens (don't ask)… Steven Tyler (deviated face).
STILL LIVING: Pat Benatar.

But enough slanderous accolades. I'll let the man speak for himself. AND HE DID! For two hours of tape! Yikes. That's well over three thousand words, here chopped to bits so you can see more nubile ho's on the following pages. 'S alright. Cuz everyone who knows, knows there ain't nuthin' better in this world than a nubile ho, and one thing's FOR SURE—no one knows this better than RICHARD MELTZER!!!

(We begin our interview after Viva and Richard have been philosophizing extensively on Valentine's Day, the horrors of romantic love, the different kinds of pain this life has to offer, how all love leads to grief but how people would rather hurt than feel nothing, right? Otherwise, HOW DO YA KNOW IF YOU'RE ALIVE??? RIGHT???)

VIVA: So, uh, my questions… What song, if you can remember, did you lose your virginity to?

MELTZER: Well, there wasn't music playing.

VIVA: What?!?

MELTZER: See, once upon a time, rock 'n' roll was not always playing. In fact, it wasn't until the early eighties that I realized you had this state of sound everywhere. So, when I first got laid, I think it was the spring weekend of 1963 or 4…went to school on Long Island…

VIVA: And it was quiet.

MELTZER: Yeah…in my college dorm room with some horrible person named Enid Levine, and she became my first official girlfriend,

and now, in retrospect, was the second or third worst girlfriend I ever had.

VIVA: Well, what would you say is the best music to get laid to?

MELTZER: It doesn't mean that much to me. I guess I'd prefer that the music not be too loud. But usually, cuz I'm such a gent, I would let the woman pick the music. And there are certain musics I would not listen to. I wouldn't listen to show music. I wouldn't wanna hear Madonna or Billy Joel. But the point is, I've had sex with women who listen to Melanie, you know? She's someone who had a song called "I Don't Eat Animals (Cuz I Love 'Em)." She was this fat chick who sang bad songs about things you weren't interested in. But I remember being with some woman who had a Melanie album. The sex act crosses all cultural barriers, you know? Yourself?

VIVA: I dunno…Led Zeppelin…

MELTZER: You like Led Zeppelin? I never liked Led Zeppelin cuz I saw them as being kinda the nail in the coffin of the British Invasion… an overkill version of lesser Stones. They seemed cheesy. They always seemed like a comedy act to me.

VIVA: Well, that's really all I heard in high school. Kinda the soundtrack to my sexual beginnings, I guess. "I Can't Quit You Baby." They're all just old blues covers.

MELTZER: I've been listening to a lot of very old blues, and there's this cut, "Ham Hound Crave" by Rube Lacey. He recorded maybe two or four sides back in 1927, and then he was afraid he'd go to hell, so he became a minister. But he did what I think is like the ultimate rock 'n' roll cut; it has this line, "I don't want no kissin' / don't need no huggin' / momma got a ham-bone / I wonder can I get it boiled?" 1927! It doesn't get any better than that. He recorded a great thing and then he gave it up. He was really onto something. And I think that rock 'n' roll was much better served when it was just fish-fry music, you know, pass the hat and here have a drink of this. Just a ritual music for creating this frenzy.

VIVA: Yes. Gettin' the panties wet.

MELTZER: Does music itself ever get your panties wet?

VIVA: Yeah, sure!

MELTZER: Really? Cuz music itself has never made me stiff. It's the thoughts themselves.

VIVA: So, is there a worse time to be alive than right now?

MELTZER: No.

VIVA: I agree. And it's only gonna get worse.

MELTZER: It always gets worse! But the fifties were pretty bad. If rock 'n' roll hadn't come along to redeem the fifties…the best you could've hoped for was to grow up to wear a tie to work every day. But then when I was eleven years old, I saw Elvis on *The Ed Sullivan Show* the night before I was going to go to junior high for the first time. It was insane! The sound delivered me to a different place, and it did this for a hundred million kids! My parents could never tell me what kind of clothes to wear ever again, or how to comb my hair. I'd seen this movie *Invasion of the Body Snatchers* with Kevin McCarthy. In it these pods take over and turn everybody into these unfeeling androids. And Kevin McCarthy is on to it, "What are we gonna do?!?" And in the end he just about gives up and has this look of surrender; it's the end of the world. And Elvis had the same exact look! I don't even think I related to it sexually. It was just the madness of it. He had the same look as this guy in a monster movie, and yet it was celebration. It reminded me of monster movies and wrestling.

VIVA: And for an eleven-year-old, that's the height of it, huh?

MELTZER: Yes! And wrestling was good then! I can't even watch wrestling today.

VIVA: Now they've got that wrestling football team where hopefully people will actually die. That's what the consumer wants to see.

MELTZER: The XFL. When's that on?

VIVA: I dunno, but I hear about it all the time. People love it. Real blood! Reality is getting to be something you only experience on TV.

MELTZER: Yeah, and that's what's so bad about it. What the sixties were was the only time since TV came to take over when kids stopped watching television. There were things to do! You know, play some sides, smoke some dope, and if all else failed, you'd smoke more dope and turn on the TV with the sound off and make fun of it. That was the only function of TV: a joke. So they had to figure out a way where this would never happen again, and that was MTV.

VIVA: That's the nail in the teenage coffin, huh? Jesus. So, what's the best Dylan album?

MELTZER: *Time Out of Mind.* The thing that got me was that it's

the most fully evolved, fully developed album on the theme of death and dying. Every cut is about "Going down the road…I'm bound in irons…they're taking me to the train….trying to get to heaven before they close the door… " It really got to me.

VIVA: Best Stones record?

MELTZER: *Aftermath*. It was the first album they did where they wrote everything on it.

VIVA: Who's better, the Beatles or the Stones?

MELTZER: The Beatles. Without the Beatles you have no Stones. They were totally influenced by the Beatles.

VIVA: The Beatles get such a bad rap…

MELTZER: Cuz of McCartney.

VIVA: And their songs aren't as clearly about fucking, I think.

MELTZER: Well, that's a fact.

VIVA: What's the best rock song of all time?

MELTZER: Have you heard of "The Fat Man" by Fats Domino? Some people consider it the first rock song as such. It's from 1949. The lyric is, "They call me the fat man 'cause I weigh two hundred pounds. All the girls they love me 'cause I know my way around." Two sentences! The Ramones always reminded me of Fats Domino. He was a real dumb guy who just had this primitive grasp of music. And the Ramones were just dumb guys who kept it simple and did sorta similar music.

VIVA: Who's sexier, Patti Smith or Debbie Harry?

MELTZER: How about neither? Patti Smith I knew as a friend, a good friend. The day Jim Morrison died we sat around in our underwear and drank 151 and listened to Doors records. I'd lay my head on her tits or put my hands on her cunt, but never fucked her.

VIVA: I hear she has great tits.

MELTZER: She has enormous tits! She'd wear these outfits so that ya never knew, but she had great tits. She was in many ways a very girly-girly girl. I didn't see anything androgynous in her at all. You know, she smelled like a mammal; I found her very appealing. But the second she transformed herself into a rocker chick she went from being completely real to completely fake.

VIVA: Do you still have a Patti Smith pubic hair mounted somewhere?

MELTZER: I don't know if I ever really did… I had a hair, and I

remember putting it into my wallet. There was one occasion when we were sitting around and I said, "Well, Patti, I'd like to fuck you some-day, but I guess there's really no rush." And she says, "Yeah, we could do that some time." And I reached into her pants and came out with a hair.

VIVA: Sexiest song of all time?

MELTZER: The first record I bought, Elvis's "Hound Dog" and "Don't Be Cruel." The greatest two-song single of all time. They're two fuck songs! One of 'em angry and the other not so angry. "Don't Be Cruel"—there's a part where he just goes "mmm!" It was just so rude! All these nuances of "uh-fuckah-me-babay."

VIVA: Would you rather go bowhunting with Ted Nugent or drink 'til ya puke with Lemmy Kilmister?

MELTZER: Lemmy for sure. But I don't wanna puke. I don't like puking. I've only puked once since I got to Portland and that was only cuz I drank tequila for the first time in many years. Well, twice. The other time was beer.

VIVA: What color panties are ya wearing and how long have you been wearing them?

MELTZER: Black, and fresh today cuz I took a shower. Yourself?

VIVA: Lessee... Um, I've got cute little gray ones on. T-back with pink zigzag borders and this naughty little pink ladybug on 'em.

MELTZER: Very nice.

I'll Take Manhattan, Part 1
May 2001

No one to talk with, all by myself... I'm smokin' anonymous in the sexi-est night I've felt in ages. An impending storm, after months of bitter cold. Sudden warmth, mugginess, my whole body feels hungover, and then a cool breeze whistles in off the water. It's wet. The sky is twenty shades of gray and slowly enveloping the whole city. It twinkles gray and yellow like an old black-and-white movie. The electricity is intoxicating.

A perfect night for film-noir-style true love, but I'm in love with the pavement.

I'll tell ya 'bout Manhattan. It's a small town. It's *Sesame Street.* A giant screwed-up multicultural ultra-lingual family that loves animals and builds its days around colorful numbers and letters. A-C-E! 1-2-3! Uptown Downtown Crosstown. It's wondrous. It's wonderland. It's all soul and bottomless hope and strong backs. It's absolutely fabulous.

I'll tell ya 'bout freedom. Freedom IS just another word for nuthin' left to lose. And what else, Janis Joplin? Get it while you can!

I live in Brooklyn. 'Round the corner from Love Lane, where Henry (Miller) lived with June. Down the street from Norman Mailer. Where Capote dreamed up *Breakfast at Tiffany's.* And I walk streets immortalized by "Tangled Up in Blue" and "Famous Blue Raincoat." It's lonesome.

I'll tell ya 'bout David Bowie. I MET HIM! Week One at a Chelsea gallery with the lovely Iman. I gushed about how I love to strip to *The Rise and Fall of Ziggy Stardust and the Spiders from Mars,* and he claimed he'd never seen it done! Right, sure, David. I asked him what he thought was the best song to see a girl get naked to. He said, "Well, gosh! I imagine it'd have to be some kind of hymn. Perhaps 'On the Wings of a Dove'…" At which point he started singing "On the Wings of a Dove." I called my Daddy Las Vegas, the Midwestern minister, first thing. Meanwhile, the rich girls with lesbian tendencies in superfuzzy tight sweaters clucked about who was a model. Who CARES?

I'll tell ya 'bout the greatest music I've seen in months. Two-way tie between Japan's kinetic godzillas, the King Brothers (oh my!), and this amazing five-piece playing perfect '60s girl pop on the platform for the S train. Five African-American teenagers—three girls with guitars front 'n' center. I could have died. But had to catch that S train.

My other new favorite band is the Dictators. They RULE! And have since 1975 or so… And I would have never heard of them if I hadn't had a special introduction to lead Dictator, ex-wrestler Handsome Dick Manitoba (thanks, Richard Meltzer!), the nicest man on the Lower East Side, who eventually got me a JOB bartending at Niagara on 7th and A.

And why have I never heard *Aladdin Sane* by David Bowie? Who is

responsible? Am I going to have to take the train BACK through NY, PA, OH, IN, IL, MN, ND, MT, WA, and OR just to strip to "Panic in Detroit?" "Dear David, I lied. 'Panic in Detroit' is the best. No. 'Moonage Daydream.' No… "

And I'll tell ya 'bout movin', cats. When you're down and out and desperate but somehow on fire, no one loves you more than NYC. And I love it back! I love NYC.

I'll Take Manhattan, Part 2
June 2001

Yeah, yeah, New York's great and all, but it's expensive! Everyone says so, and they're right. It's not just the steep rents and pricey groceries, it's the goin' out and doin' the town every friggin' night. Drinks, dinner, shows, Statue of Liberty, Yankees games… plus admissions to the Met, the MOMA, the ballet, your friend's play…it adds up! It can come cheap, and I'm learning how, but ya gotta WORK. And everyone in New York does. Most of 'em a minimum of nine to five, Monday through Friday. How weird, huh, Portland? I still haven't wrapped my mind around it. But here's the rub: I got no friends 'til 6 or 7 PM. What to do? Get a job?

So today I'm tryin' it. Got here at 9:30 AM. Watchin' the clock 'til it says 5:30 PM. Ugh! I feel suicidal! But the fact is I'm getting paid to do nothing. NOTHING! I'm still trapped, so that sucks, but I got this great view of the New York Public Library, where all the lucky people who still have their freedom are sunning themselves on the steps, flanked by the two stone lions named Patience and Virtue. But what the hell am I doing here? I could be Woody Allen! Should be Woody Guthrie! Wherefore the guitar and the dream? Oh yeah, I'm getting paid to do nothing. NOTHING! 'Cept write this column on someone else's legal pad. But I remain trapped. By whose definition? I need this check.

I am doing exactly what I've always railed against. I am a sellout.

Who else sold out? Lotsa writers. Tons o' musicians. It's temporary. It's grist for the mill. What am I drinkin'?!? Office coffee?!? Outta a paper cup? Who am I? WHO AM I? Will familiarizing myself with the fine art of the con improve my expositions on the fine art of the truth? One can only pray. And soon, soon there'll come a day when I'm back in the driver's seat ridin' roughshod, tellin' it like it is. That Moby sucks and no rock critic ever really listens to music.

But for now I'm jugglin'. The fine art of the juggle. I'm good at it. Just so happens one or more of my lemons is rotten. There is NO money worth this. Jail would be a nobler alternative. To choose this is unforgivable. Cuz these lemons lead right to the rotten state of Denmark and I'll be Hamlet in no time if I keep this up. Or maybe I'll finally learn the true meaning of the martini, but not of Patience and Virtue. Oh, you lions, free me from this prison!

Hey, Viva, it's only a one-day stand. Your princess soul smarts, surely, but a girl of your whimsical philosophies needs to stick a pinky toe in the lion's den now and then to remember the true leaden definition of WHORE and how it feels. You'll not be beguiled. NO!

Feel the salty sea breeze of his tiny beats on your face, and the warm squishy sand of his soulless stolen melodies between your toes. Yessir, this Moby guy is really something!

They always said I'd be great at sales…

NYC Strip
May 2001

Note: most of the following establishments are, sadly, gone with the wind…

Been runnin' around Giulianiville for almost a month now, and let me tell you, it is sexy as hell. Tons of beautiful strangers trapped together on sidewalks and subways every day. Often times you make eye contact with one of 'em from across the train, get into a supercharged staredown, then watch him get off at Bowling Green or Delancey Street, never to

be seen again. Which is why everyone's so much more bold here. If some chick tells you to fuck off, ain't no thang, cuz you'll never ever see her again. I've been approached several times now after a subway ride, and it's been good for at least one free dinner every time. Which, considering my current destitute circumstances, completely rocks. Plus the boys here are so totally fine...

There are a thousand and one sexy things to do every day, like walking past a basketball court, or people-watching from a bar as the girls mince by in their crazy stiletto boots, or listening to four striking six-feet-tall women coo over some boy's fluffy little Shih Tzu in a sweater.

There are unsexy things to do to, like go to Times Square, that hideous altar where our nation's soul is sacrificed daily, or to a Manhattan titty bar. Well, it's not THAT bad, but I have been sticking my head into the strip clubs, for employment and enjoyment, and what the mayor hath wrought ain't pretty (for starters, world-famous Billy's Topless in Chelsea will soon be a DELI).

For those of you who don't know me, let me forewarn you that I have peculiar taste in titty bars. I like a joint to be sexy and human, and not a tit-factory. I prefer that there be alcohol and ashtrays available, as opposed to ten-dollar soda pops. I like the girls to laugh and be themselves, not Russian ice queens who storm about soliciting efficient lap dances in Stalinesque sign language... That said, here are some places in the city-of-dreams where you can still see an all(most)-nude girl AND have a cocktail. (Giuliani forbids you from seeing pussy or even a single stray pubic hair while you have a drink. All the following are topless + G-string UNLESS noted.) In awesome-to-yucky order...

The Blue Angel * 24 Bond St. * 646.638.0120

If you're a fan of the movie *The Blue Angel* or the film *Cabaret*, you'll love this club. It's THE ONLY place you can see some pink and sip some wine or whatever (provided you bring your own). The Blue Angel is a cabaret performed in a legitimate theater near SoHo. Twelve-plus girls show you their hearts and souls and more for only a twenty-five-dollar cover (tips appreciated). FABulous German hostess Uta sets the tone with her voluptuous body, red hair, and bizarre commentary in thickly

accented Deutsch. She'll introduce you to Natasha, the ONLY female sword-swallower in the world; Ammo, the naughty nun; Velocity, who does a riot-grrrl Marilyn redux to her own band's music; Bonnie, the drunken Ann-Margret chanteuse; Ula, an amazingly sexy trapeze artist and contortionist; and super-hotties Dillon and Asa, who do more conventional striptease routines with anything-but-conventional beauty. The cast of performers changes frequently, but one of my favorites has been around forever. Nadia is a magician from Russia who is not afraid to play with fire. Last weekend she accidentally set the stage aflame! At a certain point in her show, her cape vanishes to reveal a very curvy body in a sequined corset. She has a very Russian blonde bob, long false eyelashes and very shapely legs. She is seventy-two. Seriously. And, oh yeah, I'm there, too.

*Baby Doll * 34 White St. @ Church * 212.226.4870*

This joint is nuthin' like the Louis Malle movie. Many people describe it as "ghetto." When I went to check it out, the nice Sicilian management told me I'd do well there, as they hadn't had a Caucasian girl in years. What actually sold me was that there's only one stage and one girl at a time; you can spin your own music and there's plenty of tequila, etc., all of which greatly facilitate preachin' the gospel, if that's what ya gotta do. I worked on a Tuesday night with Beautiful, Li'l Bit, Chi Chi, and a dancer named Wednesday. The place was dead, but the girls and management were so friendly they more than made up for it. Everyone shrunk in horror when I played an entire New York Dolls set, and then later, a Velvet Underground set; but the Wall Street White Guys sure seemed to appreciate it. In short, this place is a dive. I love it.

*Pussycat Lounge * 96 Greeley @ Rector * 212.285.6100*

Deep in the heart of Wall Street. Ya didn't know it had a heart? It does: the Pussycat. This place is set up like a diner, but drinks and sushi are served instead of frappes and sodas. It's smoky and divey as hell, and I, of course, appreciate that. The girls are quirky and sexy and parade around topless on a catwalk that is just behind the bartender. They seem happy to stop and chat with the businessmen—probably giving the dancers stock tips.

*New York Dolls * 59 Murray St. * 212.227.6912*

Another Wall Street joint for those three-martini and two-lap-dance lunches. Lotsa girls, lotsa smoke, lotsa crap music. They say you do a song onstage, then three off, but how do ya tell when the song is over??? When the homegirl next to you starts unceremoniously retying her barely-bra thingy, that's when. It's too well-lit and cramped for the lap dances to be very erotic. HOWEVER: The stock indexes scroll by on a giant LED screen behind the squirming babes. Excellent. The band (of the same name) is better.

*Flashdancers * 53rd & Broadway * 212.315.5107*
*Scores (tie) * 333 E. 60th St. * 212.421.3600*

The land of the lap dances. I HATE these places. These are the afore-mentioned tit factories. Totally heartless, totally soulless. High cover charges, "pretty" and "enhanced" girls, crap music. If you're getting a lap dance, chances are you're rubbing thighs with the dude next to you who's also enjoying staring at the backside of that bleach-blonde Russian. It's cramped in Lapland! I did get turned on by this Russian girl who was storming around soliciting the above... I stopped her for two seconds to ask her where she got her hot coiffure, and her icy façade melted into giggles as she stuttered that she didn't know how to say it, but he was in Brooklyn. Aw, honey!

The bottom line, Pornland, is that you are LUCKY. You've got the best titty bars in the world...and they're right off the bus mall! You can drink, smoke, see some gal's pussy AND get a whiff of her personality for NO cover and a reasonably priced drink! God, I miss it. But there's a fight to be fought here, ya know? If I could have five or ten of Portland's best and brightest, I'd revolutionize this town. Especially with Giuliani on the outs. There's your invitation, girls. Come out, come out. We'll take over the Baby Doll, and then the world!!!

xoxo, Viva

(Checks and money orders can be sent to Viva c/o *Exotic Magazine*, marked "URGENT.")

Follow Yr Bliss to Homelessness
July 2001

Been travelin' again, this time to Venice, Italy, which is the most beautiful creation of man's I've ever witnessed. Birthday-cake houses with cobblestone streets and myriad elegant stone bridges, all connected by blue-green Mediterranean water. Sprinkled here and there are enormous empty churches and bizarre half-naked half-humans. Sure, much of the time it's a veritable sewer, and all the time it's swarming with hordes of white-as-they-come tourons, but visually it is breathtakingly, heartbreakingly gorgeous! And if ever you get sick of bumping into gelato-eating Germans, all ya gotta do is walk over a canal and Venice is all yours—an empty Eden with nary a pigeon to mar your path—all moss-covered lions and Renaissance mansions. No cars, no mopeds, not even the swish of a passing gondola. Just an utterly gorgeous ghost town with its deafening post-apocalyptic silence. And why's that? Cuz NO ONE LIVES THERE.

Venice is an amusement park nowadays. It's for tourists only, and the price of admission ain't cheap. Which makes the place ring rather hollow—what is a place if no one lives there, no one calls it home? Got me thinkin' 'bout home. You know, is home where the heart is? Where the heartbreak is? Or, as Andre Williams said as he placed his red pimphat on my head, is home where ya hang your hat? Dunno. But home is not geography: street names, architecture, land forms. No it's not, Miss Las Vegas, tho' I seem to have thought otherwise, romancing the plains and grain mills of my birth, the Lutheran hymns sung off-key in cracking elderly voices, Highway 61, Lake Superior, Magic Gardens, Mary's Club, Satyricon...are these things home? I thought so. I was wrong. Home is people. Flesh and blood and souls and the dramas they enact in the street, schools, churches, and even strip bars.

I am such an intimacy-fearing ice-cold romantic beautiful loser. It's like I've already planned my epic ending off some high bridge into some cold water. I live my life like a tragic poem. Always on the run, always running away from home. Now I've run away from Portland. Why? Cuz I couldn't see the next chapter? Cuz I wanted to impose bookends on the chaos of life? The Portland story began 7/21/96, ended 3/21/01. I made sure it had a beginning, a middle, an end.

Most writers and artists have passionate allegiances to HOME, a place that birthed them, reared them, tortured them. A place they mythologize, demonize, record. I on the other hand wax passionate about homelessness, the road, loneliness. Home for me has always been the last place I left. And now I'm wonderin' if I don't leave merely to achieve the idea of a home.

I think my art would improve if I could just stay put. Get a bit intimate with a place, its people. Try to love, try to write about it... Could New York be home? Seems like everybody's mythologized it, but nowadays hardly anyone is from here. Someone told me I was already the quintessential New Yorker, bein' (a) not from here, (b) fabulous, (c) beautiful. And it's great livin' here, great to create art here, but it's not home. It's a giant Monopoly game that I'll play while I'm in the mood. Then, please GOD, I'll go home. Or create/embrace/accept a home. Why is it so hard for me? The comfort and security feel like death. But, says Mom, flowers bloom only when planted.

You know, I even think I know where home is. But I'm not tellin', not yet.

Miss ya, Portland. But otherwise doin' just fine. And hey, thanks for the money, those who sent checks. I'm toastin' your health from afar.

Kiss Kiss
August 2001

Been learnin' a lot, test-drivin' age-old mysteries and dubious truths. Here are some results:

1. Paris, France, is the city of lovers for one reason and one reason only: Paris delivers the most fantastic fuckin' orgasms EVER.
 1a. Italy's orgasms are more frequent and longer...more languorous, but quite forgettable in light of those in the City of Light.
2. New York in the summer is sex. There's no room for anything else.

Hot, humid, plus the usual thrilling everyday RIDE, thrown altogether and it throbs like my insides.

3. Best Summer Outfit: A. Smile. B. Hippy shake. Walk that down the street. C. Thunderstorm.

4. SCENT is DESTINY!!! The nose knows. Love = luck + chemistry. Do it doggy-style and go sniffin' 'round to figure out which fuckup's gonna be right for your gene-mixing experiments (and, more importantly, will therefore make yer blood boil). Ran into this big ape of a guy I knew and wouldn't talk to in college...said he heard all about it on the *Discovery* channel. Seems we animals look to mix with our opposites to create more diversified immune systems and thus live forever. Ignore this info at your peril! Especially in NYC. Who cares how rich/tall/handsome/Jewish he is. He's gotta make you HUNGRY. Find out what he had for dinner, and if you wanna get invited over for leftovers. No sommelier? Tear a page from *Vice* magazine and have a sniff of ass. You'll know for sure then.

5. Hound dog came sniffin' after me, found his way into an empty bar I was tending. Lotsa dogs been comin' round. I must be pretty pungent. This one, a huge dark hulk of a man, was a musician, was biting his lower lip, was turnin' me on with his eyes and was the definition of blatant. Said he's a "detail guy"—loved my eyes, my hands, and had somehow memorized the exact shade of tacky pink I'd painted my toenails, still hidden behind the bar. Loved my feet, wanted to rub them, said:

"I can smell you from here."

"Oh yeah? What do I smell like?"

More lip biting as he grinned mischievously and pantomimed "Come hither" with his come-hither finger. Aha, that explains everything, like why all the dogs in these parts keep runnin' straight for me, stickin' their noses near my crotch; it's quite a sight... (Already been interviewed 'bout it for *New York* mag: "What's my secret?")

I giggle and blush and get turned on and so turn my attention to the street, where the everyday parade of the most colorful, fabulous, down-and-out up-and-coming on God's green earth are oozing by in the thick-as-pea-soup heat. The girls are barely dressed, each one a neon billboard for fertility with full breasts

thrust forward, tummies bared, asses wriggling in the oldest, most effective come-on of 'em all...except perhaps for that come-hither scent I seem to be exuding...It's got 'em all beat! I imagine what it would be like if we all wised up and started following our noses, stopping to sniff, grope and mount. In Indonesia, the definition of the word for kiss—cium-cium—is "to sniff." And kisses over there, in that land drenched in hot, wet eroticism, are little sniffs and nuzzles. Over here we got New York City, which in summertime is the definition of hot, the definition of sweaty. Crack it open like a ripe cantaloupe—so succulent, sweet and juicy...gives ya somethin' real nice to suck on.

New York City, 9/11
October 2001

I was awake at the dawning of the new world.

I got up early that day. I had coffee, thought about what to wear. Took a hot bath. Wanted love, real estate, and rock 'n' roll.

I was surviving after five months in the naked city, and feeling pretty damn victorious about it. I was loved and respected and had even managed to beguile two local fishwrappers to dish on my persona that very week. *New York Magazine* was running a piece about my sexual exploits called "The Newbie" (in which I was described as an atypical ex-stripper with a first-class education and cowgirl eyes who covers her mouth when she laughs) and in days my first big piece (regarding my first big love: rock 'n' roll) would appear in the *Village Voice*. Portland friends were coming to visit for the CMJ music festival and I was closing in on an apartment and a drummer. The weather was perfect. It was Fashion Week. It was September 11.

I ran to catch my subway at Borough Hall in Brooklyn. It wasn't packed like it usually was. I got cozy for the ride to midtown as the train lurched under the East River and into Manhattan. By Bowling Green I got a seat. The next stop was Wall Street, and the end of the world as I knew it.

At Wall Street, a handful of guys in suits got on, looking about as happy as guys in suits EVER look. They were chattering like gossip columnists at a wedding, something about airplanes flying into buildings. The World Trade Center. And that this was probably the last train in any direction that we were on, hallelujah, and that they were goin' to New Jersey.

The atmosphere changed perceptibly. I glanced around the subway at everyone else who was glancing around the subway. We were petrified. The train stopped at Fulton Street, right under the World Trade Center, and the doors seemed to never close. I did not want to be underground. I wanted to run the hell out of there and keep running to the South Bronx. Or to South Dakota.

Each subway stop offered its own destiny like a choose-your-own-adventure book from my childhood. Brooklyn Bridge: I could run home to Brooklyn. But if the shit hit the fan, I'd be stuck there, on Long Island. I'd played enough Risk to know that. If I got off at Union Square, I could sleep off this nightmare at a friend's house: all the late-night Village people were undoubtedly still snug in bed. But again, if this was as bad as it sounded, that whole area might be pretty ugly, too. So I stayed on 'til Grand Central, my usual stop, and dutifully went to my two-day-a-week, nine-to-five copywriting job, unsure of what else to do.

When I got to Fifth Avenue, there were hordes of people gawking in horror at the towering inferno down the street. Some were crying. All were on cell phones. I went in to my office where my boss, the author of the businessman's bible, *The Power of Yes*, tried assuaging me with statistics: "The odds are one in eight million you'd be on that floor when the plane hit...just relax and find some work...probably more like one in ten million..."

Hadn't he heard there were two planes? i.e., HIGHLY CHOREOGRAPHED TERRORIST ATTACK?!? All the secretaries were crying. The Pentagon was hit. My supervisor grabbed my arm, saying, "Let's get some tea and get to work." Instead we went to see Evelyn, who had a daughter on the eighty-third floor. That girl was dead. We all knew it.

I was out of there. I might be the new kid in town, without that New-Yawk-tuff to talk me down, but I had survival instincts and they were screamin'. There were other targets all around us: Times Square,

Grand Central, the Empire State Building, the U.N. Building. I was Snake Plissken. I was *Escape from New York*. I was walkin' to Connecticut in my slutty Florentine boots (not quite made-for-walkin') and carrying a five-pound Proust novel (not quite made-for-carryin').

Walking up Park Avenue, I was most shocked by all the people doing their normal New York things. The gal on the corner was still distributing flyers advertising $3.99 lunch specials, as if this mass migration of people might be her big break. Old dudes were still lookin' me up and down and young dudes hollered and whistled from cars. Near the Met, a t-shirt guy was straightening his wares, many with that old familiar skyline, the skyline of the old era, the old civilization, an age of innocence when people wrote magazines about clothes.

But it's all over now, baby blue. The soulless silly zeitgeist that was the best my generation could dish up is dissipating with the dust. This horrible cataclysm has given our lives gravitas we've never known, and overnight. Entirely new ways of surviving are percolating on the streets of New York. One can only pray what results is not an era of terror or vengeance, but of heightened consciousness, faith, and love. And subsequently trenchant art, words, and music.

By Wednesday the 12th, when the new era was self-evident and there was no turning back, what was most haunting and bizarre about this island-wide crime scene was how normal and calm everything was: how New Yorkers were desperately clinging to their little everyday rituals, and how these little things—getting out of bed, buying orange juice, riding the subway, walking the dog, writing about clothes—will rebuild this nation more than billions of dollars of federal aid or the second-grade sound bites of our President and all his men and women. These people have got the weight of the world on their backs, and they look it. People have turned inward; they've been brutally reminded what's really important and they are sad, so sad. But they know where to turn for help. They turn to each other, and they turn to their God. This is one town with a heart big enough to heal the whole nation. And I heart it more than ever. I heart New York.

Meanwhile, back at the ranch, Mom's burying her head in the *New York Times* and Dad wants us to have our passports ready in order to move the Las Vegases back to Norway. But I've listened to his sermons enough times to know what I gotta do right now. I'm walking the NYC

streets; I'm sayin' I-love-yous; I'm listening to strangers. Cuz the most important thing in times like these, says the Reverend, is just to be present.

Love Stinks
November 2001

This year for Thanksgiving you get irony with all the trimmings. Irony's not dead. It's just darker and more trenchant than it was. Have a bite of this column I wrote back on September 10 for Exotic—the eve of destruction. Didn't send it the next day, because, well, you all know what happened then. If you're bored in the dressing room, try out some Mad Libs on this prose: every place where the word "Love" occurs below, substitute fate/death/religious fanaticism/war/anthrax/the World Trade Center. Or just the word pizza.

It's in the air. It's everywhere. It's the hottest thing on the streets this season. And it stinks to high heaven. It's love! New York City is a town where everyone is obsessed with/searching for/talking about LOVE. NYC loves love more than any place on Earth. But how can love be born in this city of the half-second attention span? Where everyone is impatiently jetting off here, there, and too busy to really smell flowers or pheromones? When love happens here it must be sudden and mortal, like a car wreck. People chase love. They are chasing their tails!

NYC love = office love; need-an-apartment love; need-a-roommate love; need-a-job love; need-some-money love; dog run love; need-to-have-kids-NOW love; love-your-latest love. But mostly it's talking-about love. It's literally all anyone ever talks about: the Wall Streeters buttoned up in their olde bars, the little gangs of black kids on the streets, the queers in the bistros, the trash-talking babes on the trains, the old folks on park benches, the moguls in their limos. Screenwriters, celebrities, doormen, the wicked and the wise, even the hipster nation talk about love constantly in whatever academic way is permissible to

talk about this issue. And folks fall in love at the drop of a hat. If it smells good, looks good, or sounds good, go for it! Everyone's clocks are tickin' and it's a mad race to the finish: 1.5 kids + 1 dog in a New Jersey 3 bdrm.

Now, should I join the runners or run the fuck away? What does the radio say? Love is the Drug. Love is Strange. Love Hurts. Love is All You Need. Love Can Make You Happy. Love Will Break Your Heart. Luckily the seen-it-all cab drivers are more than willing to offer their worldly wisdom on matters of the heart.

The Pakistani at 3 AM notices me glowing incandescently but cautions me with the words of the immortal Britney Spears, who says NO! to sex before marriage. And can I imagine how difficult that must be when your boyfriend is Justin Timberlake of 'N Sync?

The Indian cabbie the next night says, full of insinuation, "You know what they say in my country—you have to rub gold to see if it's real!" Yeah, yeah, rub it. And go tell that to the Pakistani. No wonder you folks don't get along. He also keeps saying, "It takes two hands to clap! It takes two hands to clap!" Uh-huh.

The Greek at 5 AM—clearly psychotic and driving like an Africabbie—recommends race-mixing. "Nothing is more beautiful!" he exclaims, showing me photos of his Filipino wife and lovely twenty-something daughters, leaving only the good Lord's hands on the wheel to steer us back to Brooklyn.

I get home to my 2' × 4' room and mull it over on my single mattress on the floor. When I tell folks about it the morning after, no one can believe that a cabbie got chatty with me, much less offered advice on love. Obviously, I look like I need it. But I'm learnin', even if it is the hard way, and who knows? Maybe someday I'll find myself driving a cab, offering unsolicited advice to tired little girls at four in the morning. And it'll be the J. Geils Band for me, man. "I've had the blues, the reds and the pinks…all I can say is…LOVE STINKS."

Back in Portland
December 2001

So ya noticed. My naked ass is back in town. People keep askin' me why I came back and I feel obliged to provide a litany of excuses, when really I have no idea! I'm not sure where I am, who I am, or how I am. So let's puzzle this out together.

REASONS I'M BACK IN TOWN

I'm a spoiled brat, and it's your fault.
I am totally addicted to stripping. I love it love it love it. I work fifteen hours a week to enable my princess lifestyle and spend the rest of my time doing whatever the fuck I want! Part of the reason I left was to get off the sauce. Stripper rehab. But Kitty's words kept echoing in my head, "It's the best job out there. Why not do it for as long as you can?"

By August it seemed clear she was right. Manhattan had given me everything I asked for. I was performing as a naked girl, guitar girl, and writer girl. For the most part, I made my own schedule and was Holly Golightly and a whole lot more. But my dark secret—that I spent two days a week as an advertising whore—was breaking my spoiled-rotten heart. I started to think that people who lived in New York City were all nuts. Deluded dreamers. Just like me. But I wasn't ready to submit and was not about to put in one more hour at a dreary office job doing brain-melting fuck-all, waiting to die. Especially after "the incident," when death seemed imminent—a punishment for dicking around a midtown office against my better judgment.

My cats are spoiled brats and were three thousand miles away.
I realized there was no way I could shoehorn my fabulous Pornland lifestyle into a two-bedroom townhouse, much less a king (bed)-sized room in Brooklyn. But my darling children (Punk and Simone Ramone) were still living in the lap of luxury. Could I convince them to relocate when I wasn't convinced myself? I decided this issue had to be resolved by the holidays. Cuz cats love Christmas. Also, two thousand dollars per month for a closet is unacceptable.

Those damn terrorists.

Although I tell myself it wasn't a factor, who am I kidding? New York changed overnight. Within a month work had dried up, lots of folks had bailed and the entire island was settling into a very un-Woody-Allen schizophrenia of depression and anxiety. Those of us who relied on the subways got the added thrill of playing Russian roulette several times a day, with all the anthrax scares and bomb threats. The city's mood was most noticeably low on the subways, which were always rush-hour packed since service on the busy Broadway line had been rudely and permanently interrupted when a couple buildings collapsed into the Rector Street station. Packed but silent. Even the vagrants and crazies had seemingly turned inward with horror and sadness. Yeah, I'll say none of that mattered, but I made damn sure I got on my westward train before October 31. The incessant Halloween warnings were just too spooky.

Wartime stoicism.

When Our Great President Bush told the nation to go back to work on September 12, whether we were bonds traders, ballplayers, teachers, actors, prostitutes, or David Letterman, I knew he didn't mean for me to go back to writing advertising copy. My nation needs me right now... naked in downtown Portland! My vast array of important, famous, and good-looking New York friends saw that this was true and gave me their blessing: "The goal ultimately is to be bicoastal." Hmm. Indeed. With what I save on rent here, I can afford a plane ticket to go back to that city of dreams to work on mine. So I booked recording time with my Pygmalion producer in January and in the meantime will be filing my *Village Voice* vignettes from my enormous claw-foot tub and doing my patriotic duty on the boards at the Magic Gardens. Sounds eerily like exactly-what-I-wanted.

The real reason.

All ifs, ands, and buts aside, the real reason I returned to snuggle back into my spot in this wet, red-lit heaven, honey, was you.

I ❤ Slayer
March 2002

Every year at Valentine's I spew the same melodramatic rhetoric: "My heart is broken blah-blah-blah greeting card holiday blah-blah mating for life is for lobsters bloody-blah-blah...." And every year I sport the red lingerie decorated with little velvet hearts and slink around to my favorite J. Geils Band hit, "Love Stinks."

Well, this year it *really* stank. After approximately six breakups with approximately three people, my heart was really broken and I wished I were a lobster. Surely you know how that feels... So when I saw that Slayer was playing in Eugene on VD, I knew what I was gonna do. I called my comely blonde friend who is in much the same situation and asked her along for the ride. We slid our tightest jeans over our shapely Scandinavian asses and steered the Volvo towards Eugene. I knew I was gonna fall in love that night, I just knew it.

Now, neither of us knew one friggin' thing about the band. Everything I knew about Slayer I'd learned from Beavis and Butthead (this, it turns out, is all ya really need to know—see interview). Also I remember seeing some new-ska video with a stripper chick suckin' on a sucker and roller-skating a dog with an I ❤ SLAYER t-shirt stretched over her gigantic tits.

And I wanted that t-shirt. But I never really wanted to *hear* Slayer. Not until they deigned to play on Valentine's Day.

And so we set our scene in fair Eugene. Blondie and I warmed up with some tequila shots at a local dive where we asked the barflies a few questions about Slayer and learned to say convincingly, "My favorite song of all time is 'Angel of Death'" and "Your last record was totally awesome, a stunning departure from the few before that. Can you elaborate?" Then we sashayed our way to the tour bus, where we were to meet Mary Jo, the tour manager.

Much to our surprise, NO ONE seemed to believe we were there for an interview. The roadies ogled us hungrily and asked if we both had our tongues pierced. I guess heavily made-up blonde girls in leather and fur usually loiter outside tour buses for other reasons.

Luckily, Mary Jo showed up in the nick of time to escort us back-stage. She took us to a little room where our prey awaited us, bristling.

His name was Kerry or Perry and he DID NOT have long hair. Instead he had tattoos all over his head. (I theorized that Kerry or Perry, when starting to lose his hair, was fired from Slayer, the ultimate hair band. But he filed a discrimination lawsuit and won, under the stipula-tion that he get tattoos and do all the interviews FOR THE REST OF HIS LIFE.) Me 'n' Blondie cracked open a couple of Heinies and splayed across the couch, trying to put the poor guy at ease, but he just nervously sipped his spring water. I think we intimidated him.

VIVA: So, SLAYER, what is the sexiest song of all time?

SLAYER: [confusion] I guess I'm not really into sexy music...prob-ably the Deftones. I don't know what song it is. It's on *Around the Fur*; it's number ten ["MX"—*Ed.*], where some chick answers him....

VIVA: What about, like, Al Green?

SLAYER: WHO? I never heard of him.

VIVA: Sexiest singer of all time?

SLAYER: All time? I don't know about all time. But today I'll pick Shania Twain.

VIVA: Who?

SLAYER: Shania Twain.

VIVA: Shania Twain? Really?

SLAYER: Behind that fuckin' good-girl, all-Canadian fuckin' moni-ker of hers is a fuckin' slut waiting to be born. I don't know who she's trying to kid goin' out with Mutt Lange. I mean, what is he, like sixty and fat? But rich?

VIVA: Do you frequent strip bars at all?

SLAYER: I used to. I used to be a fuckin' titty bar magnet. But I haven't gone in a LONG time.

VIVA: Why? Do you have a Valentine now? Yeah? Where is she?

SLAYER: L.A. Shit, I just kinda got over it. I remember when I was twenty-four I used to go all the time. My first wife I met in a strip bar.

VIVA: Oh really? Was she dancing?

SLAYER: Yep. I walked in and I said, "I'm takin' that one." And I did.

VIVA: Do you have puppies with this Valentine?

SLAYER: Nope.

VIVA: Pets?

SLAYER: Well, I used to breed snakes! I used to have like four hundred of them. But they were taking too much of my time. I wanted to put more time into this, so I sold them all.

VIVA: Sexiest city?

SLAYER: Sydney. Cuz I like Australian accents.

VIVA: What's the sexiest thing you've ever seen onstage?

SLAYER: Probably years ago, when we were in Canada and they had chicks in showers onstage. I'd never seen anything like that.

VIVA: Are the kids alright?

SLAYER: Depends on which kids you're talking about. Our kids are alright. It seems like our fan base kind of recycled itself.

VIVA: I think Slayer could do that indefinitely. What's the trick?

SLAYER: That is the trick: recycling your kids. Staying relevant to your original fans as well as new ones.

VIVA: Yeah, like what's up with your latest record? I mean, it kicks ass.

SLAYER: Well yeah, it's supposed to! I think it deals with things that kids young and old can associate to [sic] and bridge the gap. I don't think we did that intentionally, it just came out that way.

VIVA: You got a favorite Stones album? You know, the Rolling Stones?

SLAYER: Nope! [Pause.] I mean, I have maybe a favorite Stones song.

VIVA: Oh yeah? What's that?

SLAYER: "Sympathy for the Devil." "Paint It, Black" is pretty cool, too.

VIVA: What about Chrissie Hynde—ya heard of her?

SLAYER: Nope!

VIVA: You know…stock question…

SLAYER: Sexy or no? Nope!

VIVA: My brother says she's got a voice that can make a guy cum in ten seconds.

SLAYER: I'm waiting! It's been about fifteen years now!

VIVA: Favorite movie of 2001?

SLAYER: *American Pie 2.*

VIVA: Favorite war movie of all time?

SLAYER: Horror?

VIVA: War.

SLAYER: All time?

VIVA: Like, have you seen *The Longest Day?*

SLAYER: Nope. Probably the first *Nightmare on Elm Street.* That movie is fucked-up. Like the girl says, "Oh, God!" and Freddie stretches out his fingers and says, "*This* is God." And I'm like, "FUCK yeah!!!"

VIVA: Favorite guitar solo of all time?

SLAYER: There are so many.... I'd probably pick something off-the-wall like Glenn Tipton on "Beyond the Realms of Death." It's the first one, the lead-in song.

VIVA: Uh-huh. Sexiest guitar sound?

SLAYER: Well, it'd have to be one of mine. Take your pick! I play Vs and I play Warlocks. I'll have to go with the 666-V.

VIVA [after super-hot and married lead singer comes in looking for his green tea with mint]: Sexiest drink of all time?

SLAYER: Rumple Minze.

VIVA: Most influential musician of the twentieth century?

SLAYER: Randy Rhoads or Eddie Van Halen.

VIVA: Do you have a favorite Bob Dylan song?

SLAYER: Nope! I couldn't even name one if I had to.

VIVA: Would you rather go bowhunting with Ted Nugent or drink 'til ya puke with Lemmy Kilmister?

SLAYER: Well, since I've already drank with Lemmy, I'll pick goin' out with Ted.

VIVA: Everybody says that! What color panties are you wearing, and how long have you been wearing them?

SLAYER: Did I change shorts today? [He checks.] Nope, I didn't. Gray. Two or three days.

VIVA: Gray. Two or three days. That's a wrap, baby!

SLAYER: I almost changed today! I don't know why I didn't....

The lead singer poked his head in again to say he thought the sexiest song would be by Marvin Gaye, and Blondie and I decided we wanted him for dessert. Alack, his wife was around for the goddamned holiday. Fucking Valentine's Day!

We were guided to the front of the stage where we caught the last

few chugs of HATEBREED and mixed with the crowd. I'd never seen so many white people in my life! Dudes outnumbered chicks about thirty to one. A pregnant girl had her belly autographed by the entire opening band: Satan's Hatchett or Festering Head Wound—I forget which.

Blondie spotted a guy with SLAYER slashed into his buzz cut. When I asked if I could photograph him, the extremely excitable chap dragged me through the sold-out crowd to meet his "hairdresser."

But in the end, it was the ROCK that I fell in love with. I'm sure many of you sisters out there in the dressing rooms know that Slayer SLAYS. Well, here's one more convert. Even though I couldn't really tell one song from the next, there was a powerful erotic energy in the aggressive delivery and repetitive guitar, kinda like the Stooges on crank. Plus, the hair choreography was really outta sight, man. And I got a new verb outta the deal. Slay. Slayer. Slayest.

Later, on the car ride home, Blondie told me the tale of her first love, and it was the most heartbreakingly romantic story I'd ever heard. We decided that it's better to believe in love and get really fucking burned than it is to be cynical. Then we changed our minds again. I left her with her cat and her cookies and went home to tuck myself into bed.

And we all lived happily ever after.

Ryan Adams: Rock Star!
April 2002

Dear Diary:

About a year ago... A buddy of mine brought a Whiskeytown CD into Magic Gardens and asked me to strip to it. Usually I say "no fuckin' way," but he compared it to Bob Dylan and I was feeling generous. I didn't like it. It sounded like limp-dick indie rock.

August 2001, NYC... A cutie-pie with a Southern accent ambled into the bar I was tending. I had just opened, and he and I were alone for a couple hours and got to know each other. He was in town with

his girlfriend, Lucinda Williams, who was on *Late Show with David Letterman* that night. He told me how much he luhhhved her and that he was the bass player for Ryan Adams and Whiskeytown. And that I was pretty darn cute.

October 2001... I'm back in Pornland on a working vacation, and some broad I'm stripping with is dancing to limp-dick indie rock. After hearing it a couple times, I think, "Saaay, this is kinda like Bob Dylan!" I peek at her CD and see that it's Ryan Adams's *Heartbreaker.*

November 2001–February 2002... I move back to town and buy *Heartbreaker* and decide that me 'n' Ryan Adams are destined to marry. I ask around a bit among bands and New York acquaintances, and everyone says he's a prima-donna dick. But no one's a dick to me! Except Zeke.

March 2002... Ryan's coming to town! So naturally I want to interview him, marry him, or at least get into the show for free. But for the first time in my life I get NO for an answer. In abject desperation, I BUY A TICKET. Five hours later, I'm takin' it off, and Ryan Adams and his band walk into Magic Gardens. Jeezuss! I stumble over and flirt and fawn and try not to propose. But Mr. Adams just broods and sneers and then scampers off to play Playstation. He generously leaves the rest of the band to me.

Later that evening... I'm wasted on whiskey and high on life. I take my new friends over to Mary's for last call where we hook up with one of my slutty stripper gal-pals. We all go over to the Benson and hang out on the beds and drink straight vodka and admire the upholstery. Then I start making out with my guy, and my stripper friend, feeling a mean competitive streak, asks for a condom.

Next day... The usual flurry of gossipy phone calls ensues. In between squeals of "giant bulbous cock" and "adorable Southern drawl," the guys call and put me on the guest list plus three. The topic of conversation quickly switches from ass-sex to what-are-we-gonna-wear.

That night... The show's a show. Ryan plays a Telecaster. Eventually we're all cozily settled in on the tour bus. My girl's playin' fawning groupie slut and I'm doing my usual "So, what's Bob Dylan really like?" shtick when all of a sudden Ryan Adams blows in like a tornado! He's mad and has his arms full of Doritos. He wants to play Playstation in the back room where everyone's hangin' out and says to the roadie, "Get them out of here now! Tell them the guy who's paying for this bus wants to use it!"

The party's over. The guys just shrug their shoulders and ask me if I want to go with 'em to Lincoln, Nebraska. They're celebrating a birthday on the way with a bit of locally harvested opium, and do I have an *I Dream of Jeannie* outfit? A tempting offer, but I wasn't gonna hang around Ryan's bitchy aura for one more heartbeat. The guy's a prima-donna dick! Sure it's hard to be so heartbroken all the time, plus he's short and people always get him mixed up with Bryan Adams, but you'd think he could've managed one tiny little hopelessly smitten glance in my direction.

In the end, I gotta give it to the guy for providing me with my first-ever genu-whine "Rock Star" experience. Plus I think that stripper I took with me might have fallen in love. How nauseatingly cute. Somebody has to, I guess.

Note: the following was in fact NOT written by Gene Simmons. I had an interview scheduled with him right before the magazine went to press and he stood me up. I was pissed and I had some space to fill. Beware a writer scorned...

Viva Las Vegas Sat On My Face,
by Gene Simmons
July 2003

I'd been on the road all day when I pulled into Portland, and I'd nuzzled up to a lot of silicone tits in the last twenty-four hours. I was about as tired as my silly band KISS, and neither the prospect of yukkin' it up for my buddy with Amyotrophic Lateral Sclerosis nor my mighty Israeli constitution was enough to pull me out of the comfort of my town car. Portland Schmortland. I was dog-tired and wanted to kick it at the Benson with some vegan yummies and the Shopping Network. I'm an old man, after all, and pretending to be a maniacal tit-grabbing goo-bag has lost some of its splendor over the years. I missed my BBQ, and Paul Stanley was taking care of my cats and last time he watched them they ate the goldfish.

Suddenly I glimpsed on the horizon one VIVA LAS VEGAS. And I tell you I woke right up. Viva had consented to do an interview for me, even though she had several parties to attend and some bands to see. She wore fishnet stockings, which I asked her to remove and then stretched over my head. She laughed her musical little laugh, and I felt like the ice was really broken.

I took her down to the basement and she grabbed a Miller Lite. I shut the door to my little green room, and she made herself comfortable on the couch. We were alone, me and Viva Las Vegas—wearing nothing but a skintight supershort zebra slip, stretched over her lovely ass and refreshingly bite-sized breasts. Yum yum yum!

I asked her straight away if she ever tried KISS Krunch, our limited edition cereal that was made in Minnesota, where Viva hails from and where all cereals are made.

"Are you kidding? How old do you think I am?"

"Please say eighteen…nineteen?"

"Ha!"

"Um, well, what is the sexiest song of all time?"

"Voodoo Child."

"Sexiest cu—"

"Take off my boots."

I took off her boots. She yanked my metal folding chair in towards her and spread her little pink toes all over my face, starting with my eyes. Thank God I shaved this morning! I swallowed hard. I had to know…

"Sexiest member of KISS?"

"Let's find out," she purred.

She kicked over my chair and started teasing my tongue—still trapped behind her fishnets stretched over my head—with her big toe.

"What a great red that is," I stammered. "May I, uh, ask…what color is your polish?"

"Chanel's Pulsar."

"Uh, umph…ahhhhmmm."

My tongue, always my ticket to ride, fought the taut strings of her Wolford fishnets as she straddled my face. Fuckin' Austrian stocking technology! My chin was in! If I could just…work…the g…

She giggled, moaned, panted, screamed. And the more I tried to

push my fish through her 'nets, the more I got into the restraints. The clouds of my warm hot breath must have formed a storm, for all of a sudden the skies broke and a torrent of summer rain ran down my cheeks, chin, chest!!! It was pure ecstasy.

She got up and left as quickly as she—uh—came.

I know she never really liked my band, but I like to think she liked me. She let me keep her fishnets, anyway. They're still stretched over my face.

Also, Hunter S. Thompson did NOT fly me to L.A. However, the guy who did was so gonzo he more than earned the soubriquet.

Hunter S. Thompson
May 2003

Remember that Duran Duran song, "(I'm Looking for) Cracks in the Pavement"? What a ridiculous thing to write a song about. I am not looking for cracks in the pavement. But when walking the filthy, cracked pavements of life, sometimes ya step in gum. And the next step, you step on a twenty-dollar bill.

The twenty-dollar bill is the gum, says Buddha. But on yr way to enlightenment it is a *delightenment* to have a twelve-dollar shot of tequila on the rocks (eight-dollar tip) and drink in the twinkle of the City of Angels. I ❤ L.A.

Hunter S. Thompson flew me to L.A. and taught me about life. He knows a lot about it on account of all the crack he smokes. He knows especially well what matters and what don't. He's pretty unattached existentially, which is of primary importance. I wish I could be. But I so stubbornly ain't. I am so completely attached that I collect tablecloths and trinkets of all the states I've lived in and obsessively read food labels to assure myself that cereal comes from Minnesota and pasta from New Jersey and health foods from California and pineapples from Hawaii.

Did you know that pineapples were a symbol of welcome during

colonial times? I wonder how they got 'em. And what the implications are when they're screenprinted and rhinestone-studded on the brand-new breasts of fifteen-year-old chiclets....

Anyway, why attachment? I think it's a general human thing to define ourselves through birthplaces and Social Security numbers and signature scents and favorite mascaras. We think that if we define our Path we will be safe and someday wind up in Cincinnati or wherever it is we'd like to go.

But the Path is already defined. As a path. And what matters is that you stay on it, not where you get off it. Or as Hunter puts it, it doesn't matter where you wreck your Porsche as long as you get it fixed and keep on driving. But the fast-food lunches and circus sideshows and dope-crack-love-meth that line our solitary streets are so goddamn tempting! So tasty and colorful, they are the Bananaberry Hubba Bubba the human foot gets forever stuck in. The packaging's all red and yellow and exciting and promises so much, but put it in yr mouth and it quickly turns to tasteless rubber.

And this is precisely why I love the human. We are programmed to fail. I always argue that other animals are superior beings, doin' mighty fine with their cool reliance on instinct. We, on the other hand, second-guess ourselves until every beautiful idea has turned into a Hiroshima. The human is the eternal questioner. Lucifer was also the questioner and sat at the hand of god (small 'g'.... My God, maybe. Maybe not yours.) They were buds and probably got high and played strip poker and talked into the wee-wee hours. Then people who discourage questioning among humans nicknamed the guy the devil. Not unlike Eve, who's blamed by certain dudes for ruining us all through her infernal curiosity and desire to taste from the tree of knowledge. And you know, curiosity kills cats and two-year-olds, and it will kill us, too. Hopefully.

VH1's Top Three Hair Metal Bands of All Time:

3. Bon Jovi
2. Twisted Sister
1. POISON

"I am all these bands and more," said the Buddha.

Marianne Faithfull
February 2003

Life is hard. Life is short. Life's not fair.

I saw Marianne Faithfull in concert recently. And thanked my stars that I wasn't dead yet. That I got to see her. Life keeps trying to kill me, trying to kill all of us. But at least I got to see Marianne.

What if you're born rich and beautiful and smart? Generally you are vapid and out-of-touch and more than likely blind. Or you're MARIANNE FAITHFULL. Still, life will try to kill you.

Hey, Carrie Anne, what's your game and can anybody play? The Hollies wrote their 1968 hit about Marianne's legendary willingness to make the road a little more *comfortable* for virtually every sixties star. She was the most lacey, whip-creamy, angel-voiced tidbit the sixties produced. She fucked Keith. She fucked Mick. She fucked 'em all. And by the seventies was adhering to a strict diet of liquor, drugs, and cigarettes. Eventually she was literally living in the gutters, strung out and wrung out. Then she put it all down on 1979's breakthrough *Broken English*. Considering her signature hit was 1964's syrupy "As Tears Go By," the pain, jealousy, and despair on *Broken English* was like finding shrapnel in your crème brûleé.

I first saw Marianne at the Aladdin, singing her broken heart out for the most motley crew ever collected: decrepit old hippies, punk rock kids, and loads of gay men. All come to revel in that instrument of hers, cracked and weathered by years of naughty muse talk and cigarettes and whiskey. Bob Dylan wrote songs for that voice. So did Tom Waits. So did Beck. So did Blur.

A few days later I saw her as a wispy youth, thirty years young at a Lower Manhattan cocktail party—draping herself gracefully, sluttily around anyone with a light, a hit, a come-on. Both nights she clutched a pack of Marlboro Lights like they were her mother, her lover, her lifeline. Without those cigarettes to hold on to, one got the feeling she'd evaporate into the night.

We all get through somehow.

I had an epiphany then, for better or worse. We *all* get through somehow. Whether you're getting by with ignorance, nicotine, heroin, sex, food, or religion, you're an addict. Life is just too rough to tough

out alone. Off the record, I spent the last year zonked out of my head on every antidepressant ever invented. And those fuckers are expensive. Watching Marianne, I thought why not heroin? Why not cigarettes? At least they're more organic, natural remedies. I know they RUIN LIVES, but life is ruination. Why not fuckin' ride it?

People on Prozac are boring. They meet boring people, they have boring lives, they write boring songs, screenplays, stories. People who medicate sub-legally have much more interesting things to say and do. And then they write *Broken English, Naked Lunch,* and *A Clockwork Orange.*

Get addicted to Jesus. Get addicted to art. Get *Addicted to Love.* But stay off those Western meds, man! Give me methadone before Prozac. Pretty soon half the population (the rich half) will be medicated on these anti-life drugs and telling us we can't smoke cigarettes or pot or opium—nature's life preservers. And we poor folk will have to get high off donuts and candy bars 'til our serotonin is through the roof and our bodies swell with fat and cancers, but they won't care. We're taking up two seats on the Greyhound, not next to them on Air France.

And they'll keep wringing their hands, asking, "Why is rock dead? What happened to the theater? Is Jennifer Lopez really the Best Actress?" Until they don't care about that either.

Ah, hell. We all get through somehow. Who am I to preach? Let them eat Prozac.

I Cock
March 2003

I love cock. I love it love it love it. Big, giant, superhuman...average, small, wee...soft, hard, smooth, hairy, I love them all. They are wonderfully magnificent little beings, even if the person they're attached to is all too often a total dick.

I am relatively undiscriminating, though I prefer my cocks to be hard. Stubbornly, frequently hard.

Some of my favorites include the stranger's cock, wrapped in blue jeans and hard as a rock, teasing me through my short skirt sitting on his lap drinking Jack and Coke and talking about stupid rock 'n' roll. Or the reliable cock-in-the-mouth, getting bigger and harder and more slippery with every suck. Or, best of all, the good-morning cock—ready to rock and knockin' softly at my pajama'd ass.

I've taken a few courses in cockology and I know that there's quite a variety out there. And that stereotypes exist for a reason. The blackest cock I ever met was also the biggest cock I ever met, and I thank Jesus to this day that that guy had a foot fetish. The smallest cocks I've encountered have been brown—Middle Eastern, Mexican, Southeast Asian— and attached to the BEST lovers. The white cocks have all been "above average" according to their owners, whose skills were ultimately below average. I don't really care. If it's hard, I'm happy.

It's come to my attention recently that many guys read much more into this cock size thing than meets your pussy. Like, did you know guys who date exclusively Asian chicks have small cocks, the better to fit in their supposedly smaller boxes? Or that the only guys who cry on account of a woman after age ten have teeny weenies? Or that Napoleon's/ Hitler's/your-band-name-here's world domination fantasies were the result of less-than-average guns? Or what about this current conflict? Your President George W. Bush vs. the evil whatchamacallits. Surely this economic stink bomb is resultant from the age-old coupling of penises and politics. Heck, if you take the *eni* out of penis and substitute it for the *olitic* in politics you have the SAME WORD. Weird!

Does George W. have a big cock? Laura always looks pretty well laid. But whose fault is that? You can get off in a number of different ways in the White House.

Who is Saddam's cock sock, and why do we never see his/her/their picture? Here's a guy whose penis envy is so outta control that he builds million-dollar mosques to himself, festooned with phallic minarets that are actually in the shape of Kalashnikovs and other military hardware— in a country where food is an unaffordable luxury. Jesus! Take a Viagra! Get a penis pump. Or just use your hands more, dude!

My diminutive Egyptian lover was the BEST. I still get cross-eyed thinking of how he would pull me into him, placing his little hand on the small of my back. He could repeat this move anywhere—in a

theater, on Second Avenue, at a funeral—and I'd wet my pants. He was also adept at that works-every-time trick of kissing a girl with your hand wrapped around her neck. This works every time! Why don't more of you dickheads use it?

The secret is to make us feel that you're in control, that you know what you're doing, and that we are literally and figuratively FUCKED. Cuz the truth is that while you boys are following your unpredictable and impetuous cocks around, suckers to the vagaries of virility, we chicks are holding things together. It's exhausting, and we need a break. If you can for half a second make us believe that you're gonna hunt and gather and kill and maim for us, we melt like butter. To this end your big cock will only take you so far. Use your tongue, hands, brain, mouth. Then use your hands some more.

Don't get me wrong—I love cock! But it's those creative cocks—the ones who start with an appetizer of chocolate-dipped toes, know exactly how to pull your hair, and do really fucking great handiwork—that you always hear about in the dressing rooms.

What's Sexy with the Cramps
December 1998

The Cramps, if you haven't heard, are superfabulous rock gods incarnate who have wrought unholy havoc among the masses for two decades now. They are: lead screamer and professional maniac Lux Interior, his devastatingly beautiful gal pal Poison Ivy Rohrshach on guitar, and an endlessly rotating rhythm section that kicks out the triedest, truest butt-shakin' blues rock to come out of this cornfield since Jimmy Carter entered the oval office. The Cramps' trademark sound pays homage to rock history's greatest heroes such as Jerry Lee Lewis, Elvis Presley, and every blues bad boy that ever breathed alongside early garage rockers The Sonics, The Wailers, The Count Five, etc., etc., ad infinitum. Lux's infectiously manic stage show and Ivy's smoldering demeanor and even sexier riffs (not to mention her footwear!!!) combine for an intoxi-

cating night of real rock 'n' roll bliss. Their 1997 release *Big Beat From Badsville* (Epitaph) smokes. Music for gettin' it on. And what a picture of Ms. Rohrshach!!!

Viva Las Vegas, the luckiest girl in town, is a striptease artiste in only the seediest sex clubs. At her very best, she can be seen slithering around to classics off the Cramps' *Bad Music for Bad People*, hollering the lyrics at mystified customers who really do love her anyway. She moonlights as Portland band The Licks' frontwoman/guitarist.

VIVA: Are you guys from Ohio?

IVY: Lux is, originally.

LUX: Well, she lived there for a year and a half.

VIVA: Is that where you two met?

LUX: No no no no no.

IVY: We met in Sacramento.

VIVA: What was she wearing?

LUX (eagerly): She was wearing…uh…well…uh…skintight…uh…

IVY: Cutoffs, Lux! They're called cutoffs.

LUX: They had a big hole in the ass and there were red panties showing.

IVY: And I was hitchhiking. People think we made that up, but people hitchhiked in the '70s.

LUX: It was me and my friend and his dog and we went WHOA!!! Check her out!

IVY: But the dog was quite gentlemanly.

VIVA: So much great rock 'n' roll comes out of Ohio. Why is that, Lux?

LUX: Well, it's because it's so horrifying there so all the kids have to do something to destroy their parents—they always have there. Plus there are a couple of really amazing DJs. You can do something completely insane there and become a hero.

VIVA: How have you kept the band and your marriage together all these years?

IVY: Well, we're not married! We're just dating… We keep one foot on another world and we didn't get sucked up by all the attention. It's better that we're a pair.

VIVA: Does this pay the rent? Has it always?

Ivy: Oh yeah. We've got a house and a car.

Viva: It's urban legend that you're a dominatrix, too, on the side…

Ivy: Oh no…not for years.

Viva: You were?

Ivy: Yes, in New York. It pays well. But that was a long time ago.

Viva: I myself am a stripper to pay the rent and a rock 'n' roller by passion.

Ivy: It's great to do it if you can. You are your own boss and you get paid for being extraordinary.

Viva: What do you think about the direction of rock 'n' roll today? Do you see any trends?

Ivy: Well, for years and years there weren't any contemporary bands that we liked and there's a lot now. Our band's not retro, but we were influenced by a lot of old records in a very eclectic way, and now I hear a lot of bands being influenced in a similar way. The Demolition Doll Rods, Guitar Wolf, the Countdowns—any band like that that can play with Andre Williams and it works. To me, all the old blues cats on Fat Possum (record label)—R. L. Burnside, T. Model Ford, Hasil Adkins—I think they're cutting edge. I think they're way more modern than anything that's going on. So yeah, rock 'n' roll is alive and well, though it's mostly underground.

Viva: It's all about a good DJ. You know, if the kids don't have a good DJ, they're never gonna hear any of this stuff.

Ivy: Right. There's a great DJ in Montreal right now. He plays the Cramps, he's French, and he's totally insane. In L.A. there's good radio, too.

Viva: What do you think about "Women in Rock?"

Ivy: You know, you pick up a magazine and it says "Women in Rock" and it's all folk singers! What's changed? When wasn't there that? I mean what's new about that? L7 rocks. Those girls are incredible guitarists. The whole band really rocks.

Viva: Who is the sexiest rock 'n' roller of all time?

Ivy: Elvis. Elvis stood up there and danced like a stripper. That's sexy! The sexiest to me was that TV special in the sixties where he wore all black leather. I think that was his sexy peak. He blossomed into this tanned man. He just seems like he's seething. Even when he sings a slow

ballad he's like twitching and fidgeting. So not even just Elvis, but that Elvis is the sexiest rock 'n' roller.

VIVA: What makes a song sexy?

IVY: Usually a certain kind of rhythm…or a bluesy chord…something slightly haunted. The Stooges you can really move your hips to. Or a sexy singer! There aren't many sexy singers out there.

VIVA: Well, have you heard Zen Guerrilla? From San Francisco?

IVY: No…tell me about them!

(At this point, Viva mews on rapturously about ZG's delicious blend of gospel/blues/ punk/soul and their intoxicating stage show, and Ivy even seems interested!!!)

IVY: Wow! I'll have to check them out!

VIVA: What do you think is the sexiest Cramps' song?

IVY: Probably none of the ones we've written, although I love playing "Queen of Pain."

VIVA: What's the sexiest song released in 1998?

IVY: Mick Collins (ex-Gories, Andre Williams) "I Can't Stop Thinking about It." It's the sexiest song cuz it's all about sex.

LUX: He's a black guy who takes sixties' white-kid punk songs and turns them into dirty blues songs.

VIVA: How about the sexiest song of all time?

IVY: "Harlem Nocturne" by—

LUX: For the best slow song, "Harlem Nocturne" by the Viscounts— or by a lot of people—and for the best fast song, "1970 (I Feel Alright!)" by the Stooges. That was back when Iggy screamed everything he sang and was, like, out of his mind.

IVY: Do you know a song called "Swamp Girl?" Frank Lane did it, but there's this great album by Kay Martin and Her Bodyguards. She was a stripper and she's in some magazines. This song "Swamp Girl" is really great.

LUX: That album is just the best album out of anything.

IVY: That might be the sexiest music aside from Elvis. There's a song called "The Heel" about her boyfriend…

LUX: Sing it! You know all the words!!!

IVY: She's saying how she knows he's cheating because she can smell perfume and she actually even tries to poison him… "The heel! The

heel!" She poisons his coffee and she watches him pick it up and sings "and I reach up and smash the cup…cuz it takes two heels to click." It's fuckin' sick! She's incredible. Too much.

[Ed. note: "out of his mind," "like totally insane," and "fuckin' sick" are obviously the highest compliments the Cramps bestow.]

Lux: Her bodyguards are protecting her with swords. That's a serious record!!! She has a Christmas album out, too.

Viva: What's Christmas like, chez Cramps?

Lux: I buy her all these sexy outfits and she wears them.

Ivy: I don't know where he finds these things…and he talks me into wearing them! Like what I wore tonight (An "insane" sheer bodysuit with translucent tattoo type patterns—baring all!!!). He bought me that.

Viva: What are the sexiest Christmas tunes?

Ivy: The Youngsters' "Christmas in Jail" or maybe The Sonics' "I Don't Believe in Christmas."

Viva: Do you guys do any Christmas covers?

Lux (lying): We do one called "Put the X in Xmas."

Viva: Mr. Interior, what was the best Christmas present you ever received?

Lux: I'm sure that if I could remember it, I couldn't tell you.

Ivy: Mine would be shoes. Lux gave me these superhigh platforms— but that black that looks like an oil slick—and eight-inch heels!!! You have to take tiny baby steps.

Viva: Finally, what color panties are you wearing and how long have you been wearing them?

Lux: I'm not wearing any panties.

Ivy: Black.

Viva: G-string?

Ivy: Oh, always G-string.

I ❤ My Ass
May 2003

If it weren't for my ass, I sure as hell wouldn't be here right now. I owe it all to my butt, and this is a monumental confession, considering that ten years ago I hated it so much that I told my mother it was unjust to breed and curse a kid with wide childbearing hips and strong round buttocks. Then I tried to kill myself the traditional teenage way—anorexia—and damn near succeeded.

I was a total tomboy. I wanted to play football and punk rock, not be ogled by my algebra teacher and wear eye shadow. My ass kept getting in the way! I tried hard to hide it in extra-large skateboard t-shirts and Dad's sweaters, but still guys came sniffin' around, saying that there was something in my walk, in my very carriage, that was so sensual, cocksure, and come hither…something that screamed sex. It was my ass. Goddamn it!

My family members are all athletes. We have big strong Norwegian butts that have kicked ass all the way to the Olympics and the NFL. One favorite tale at the Las Vegas dinner table is how baby brother needed a shot in the ass, and Doc's needle broke on his muscular glute! Big strong Norwegian butts.

Well, I HATED mine. I wasted away to ninety pounds and fainted climbing stairs, yet ran ten miles a day. Still it was there. I've got wide hip bones that cannot be altered. My ass fucking followed me every-where, threatening to kill me as I tried to kill it. This went on for years. Until I was SAVED by STRIPPING!!!

There are many who claim that stripping is empowering, allowing women control over their sexuality and the male gaze. I agree one hundred percent. It is also empowering and liberating to learn that men/women/society don't really believe what fashion magazines preach, i.e., that thin, androgynous, mutant-tall women are the definition of female beauty.

Imagine my surprise when, several years ago when I was a newbie, some young, hot guy at the rack exclaimed that my ass was the best thing he'd seen in Portland, that watching it was "like fireworks going off." I was floored. An epiphany. My ass was an asset! Guys loved it—and paid

for it. Who cares if less self-assured chicks still snicker oh-my-God-look-at-her-butt. That's their fashion-victim problem. Meanwhile I get compliments all the time that I must be half black, that my butt is the best in town, etc., etc. I've even come to refer to it, half-jokingly, as my best feature. Stripping allowed me to accept my ass.

Sometimes I still feel like there's a monkey on my back. It's not a tomboy butt. It's an inherently sexualized, überfeminine accessory that I never would have chosen to adorn myself with. But heck, look where it got me. I've got a lovely career in the performing arts and edit fabulous *Exotic Magazine*, which lets me do just about whatever I want. Like for instance this ALL-ASS ISSUE!!!

Why Do Strippers Date Losers?
October 2003

"Love is scary, like Halloween."

Thus ended my original October 2001 column. This year it's Love's Been a Little Bit Hard on Me. It's When Love Goes Wrong, Nothing Goes Right. It's What River Should I Jump In?

I've fallen in love four times in the last four years. Totally, completely in love. And man, is it heartbreaking! Each of these boys was totally dreamy, totally unique, totally sexy, totally brilliant, and a wonderful kisser. I worshipped them. And each was more of a loser than the last.

I am an expert at falling in love. It happens instantly and totally. I am unafraid of love and I never see the folly of my ways. I always think I'll never find it, then boom, love walks in the room. But when it walks out, I melt.

I only fall in love at first sight. It's gotta be instant animal attraction or I'm not interested. And the guy's balls have to way outweigh his brain. This is evidently a prerequisite. The guys I love skate through life on charisma and creativity, but when it comes to paying rent or maintaining a car, they are dumbfounded. Most of them are just breezing

through town…on the run from the law, adulthood, themselves…. It's like I want to trip them—fuck their shit up. Make 'em cross-eyed with love, saying, "I've never said this before and I can't believe I'm feeling this way, but let's get married and have babies." (They always say this!) Then I kick them in the balls and run away—a trick I perfected in first grade. I'm trying to recreate *Pee-wee's Big Adventure*, where Pee-wee tells his sweet, dorky girlfriend to get lost, saying, "I'm a loner, Dottie, a rebel!" Yet by the end of the movie they have puppies and are riding a bicycle-built-for-fucking-two. My dream!

I have been completely poisoned by Hollywood and Little Golden Books to fall for the big bad wolf and tame him. I am a world-class game player who says, "I don't play games." I am the girl who in high school renounced marriage 4-EVAH but who suddenly wants baby Vivas and doesn't want to do it alone.

Hanging out with all the other heartsick strippers, I hear a lot of the same stories. Granted, most are wise enough not to want kids, realizing that we are selfish brats, but we all want long-term lovers. And we all seem to fall for LOSERS. (Pardon me! I mean "Outlaws." "Rebels." "Musicians." "Skateboarders.")

Why do strippers fall in love with losers? We meet hundreds of eligible bachelors every day. They adore us. But it's the losers who win our hearts. Soon they've moved in and are beating us up and selling crack outta the front door (if they have a job at all) and are not coming home at night, while we wait up for them knitting little pink caps for our kitties and reading *InStyle*. Why?

Some say that we are Bad Girls and so fall for Bad Boys, that we are living on the edge and so get off on guys who live the same way, that we are "outlaws," "rebels," "musicians" and "skateboarders" ourselves.

I'm not so sure. After seven godforsaken years of mulling it over, I have my own philosophy. Strippers date losers because we can afford to.

Burlesque Is Boring
November 2003

Burlesque is, according to Tease-O-Rama's dictionary, "a witty and mocking send-up of vaudeville entertainment." Pretty goddamn postmodern, since vaudeville was generally witty and mocking in the first place. I'd say, after attending the third annual three-day burlesque convention, *TEASE-O-RAMA*, that burlesque is "fat, unpretty, tattooed girls awkwardly aping opera histrionics."

Whoa! That's harsh! I can't believe that just came out of my pen! Naughty, humorless pen.... Those Tease-O-Rama folks gave *Exotic* two free VIP passes—a two-hundred-dollar value—and I can't say anything nice?!?

That's not true. I have plenty nice to say. But the general tenor of this fat fest was so catty, so anti-stripper and devoid of any kind of sexy that I took to committing petty misdemeanors to entertain myself. I guess ya can't help but get catty at a festival full of broads.

My photographer, Lucy Fur (a fabulously burlesquey STRIPPER), and I arrived in Los Angeles just in time for the press junket, where we pressed the flesh with burlesque luminaries and overheard the New York bitches bitch about their L.A. littermates and vice versa. Very silly. Some great outfits came, no sex was had, and the Bigfoot Lodge (hipster dive) stole the show.

The next evening, after a feverish day spent shopping for shoes, corsets, panties, fringe, and rhinestones, Lucy and I settled into great seats at the supercool Henry Fonda Music Box Theater on Hollywood Boulevard. I was braced for maybe two hours of tassels, but NO! It was a SIX-HOUR flesh parade, and one hour into it, I had already seen enough shoulder-length gloves unceremoniously ripped off and tossed to the floor and was yearning to see a live pee show. I had had all the fringed flab I could stomach, and even the sight of one chick's MISFITS tattoo oozing out of her overly-tight pink corset failed to amuse me.

I hightailed it to the VIP rooftop lounge, lit up a Lucky, and downed two tequilas under the stars and the smog. There I witnessed the best show of the weekend—two old punk rockers gussied up in suits doing

a swell Sinatra bass and vox shtick while falling into folding chairs. Reinvigorated, I went down to the mezzanine where I defaced over one hundred *Spin* magazines, writing "I SUCK" on cover boy Dave Matthews's t-shirt. I didn't know how I was going to endure three more hours before headliner Dita Von Teese took the stage.

Dita is evidently HOT SHIT. I don't know because I don't care. Burlesque has always seemed phony to me—a cheap parody of sexy, absent of any and all sincerity. But enough about me. Dita is Marilyn Manson's chick. Her claim to fame is rhinestones, rhinestones, rhinestones: rhinestoned gloves, fans, shoes, chairs, tampons, etc. She was a *Playboy* cover girl, which in the hypocrisy of the new burlesque is very fucking cool and lends legitimacy to the entire movement. Mostly Dita does a soulless rip-off of the inimitable Bettie Page.

Dita was lovely. Moved like an actual dancer, like, say, a STRIPPER who dances eight-hour shifts five nights a week. She was professional and not fat. Or tattooed. Really she had nothing over Portland's fabulous gals other than rhinestones (silly) and Marilyn Manson (alright, I'd fuck him).

Speaking of Pornland…Portland was completely unrepresented at Tease-O-Rama. Sure, SuicideGirls, Inc. signed on late in the game and sponsored the show, but none of the acts were from the Beaver State. Maybe because we host a more fabulous, sexy, witty, intelligent skin fest every night of the year! But we are strippers, and as such somewhat unwelcome in the burlesque scene. We dance for a living, not to make a statement. We are willing to give lap- and table-dances. We are unopposed to getting fake tits. We are not fucking around. We are the REAL DEAL. Sexy. Witty. Charismatic. Tough.

Part of Tease-O-Rama's mission was to educate with a "bawdy history lesson," and to that effect they had seminars on tassel-twirling, teasing, the history of burlesque, writing about burlesque, and other unsexy stuff. But I gotta say that I did learn something at Tease-O-Rama. I learned that there is an "IT." There are "it" girls (Kitten DeVille, I'm looking at YOU), and there are girls who are not "it." If you're not "it," get off the stage! If you are, smile, cuz God loves you. And nothing in the history of the universe is sexier than an "it" girl, smiling, giggling, and doing whatever the fuck she wants in the face of certain doom.

Get the Fuck Off My Rack Now
November 2003

It'd been a violent week in my downtown strip-club world. I was in a fight, I witnessed a scratch match in the dressing room, and I had to cancel band practice when some psychotic drunk tried to murder my bass player but murdered her car instead.

What the fuck was going on? Were current economic woes turning men into monsters? Was it the moon? Or Mars, careening so close to our planet? Maybe just coincidence?

Nope. It was Johnny Cash, stirring things up from beyond the grave.

I got decked onstage at Mary's last month. It was my second set of the night. The place was packed. I was in maniacally high spirits, giggling through a baby doll set in a white nightie that barely covered my fluffy bunny-tail G-string. I danced to "Sunday Girl" by Blondie. Danced to "The Kids Are Alright." Then started a pissing match with a buttoned-down, mid-fifties businessman from North Dakota.

He was sitting at the rack, which was full of tippers. But he wasn't tipping and wasn't gonna. He was "waiting." And saying extremely rude and retarded things. I asked him sweetly to move. "No." I asked the staff sweetly to move him. "You can't make me."

Johnny Cash came on the jukebox, singing Dylan's "It Ain't Me Babe" with his wife June. *Go away from my window. Leave at your own chosen speed.* I picked my nightie up off the floor and danced around with it like it was an imaginary boyfriend. Then I put it back on. Cute!

Asshole pipes up again, more rude, more retarded. So I drop the baby doll act, roll my eyes, and relax onstage. "Sir, you are a real asshole." He says, "Shut up and take off your clothes."

That was it. I got on my knees and crawled over the rack so I could be at eye level with him and snarled, "Get the FUCK off my rack NOW." I was pointing at him sternly, Uncle Sam-style, when he slapped my hand away, hard.

So I hauled off and hit him. His little round businessman glasses went flying across the room and broke. Then he hit me right back. In an instant, the entire bar was up, chaos and chivalry mixing for a very sexy

effect. The guy was escorted out in a headlock by some musician friends of mine and Mary's fixture, Jerome.

Me, I'm still onstage. Johnny Cash is still singing the Dylan song. My eyes welled with tears so I swallowed hard and realized that my mouth was filled with blood. What a dick! I forced some giggles and pulled it together and finished the set. Every guy in the house came up with a one, a five, a twenty. Someone even tipped a hundred-dollar bill. Everybody bought a Mary's Club t-shirt. The bartender complained about it, saying, "I feel like I'm working at the fucking Gap!"

The stupid fuck came back in later looking for his glasses. The cocktail waitress yelled, "If I find them, I'll break them AGAIN." Vicki the boss gave me one of the lenses as a souvenir. My mouth kept bleeding all night and my tongue swelled up for a week. Now the boys call me Slugger, Bruiser, etc. They suggest that I stage fights more often. And why not? The take was pretty good, after all. And I gotta say I kinda liked it. It was a great show, and I've always said you should get decked once a year, just to remind you you're alive.

I ♥ Chihuahuas
December 2003

So I broke up with my guy. I didn't like how he treated me and he didn't appreciate me expounding on his cock or that he was a loser in print. So I called it quits.

Of course I still love the guy. Of course I wanted him back two days later. Something about stripping and having everyone adore you onstage makes going home alone extra lonesome. So after ten days without him, I flipped out.

Strippers and customers alike had promised me that he'd see the error of his ways eventually and come back like a good little doggy. The best way to get this to happen, they said, was to (a) leave him alone or (b) fuck his brother, his best friend, his uncle, his ex-girlfriend, my ex-boyfriend, and his boss. I was willing to try anything. But first I

thought I'd see if my own strategy of revealing to him that I was a psychotic nymphomaniac would make him come around. So I drove to his house, cuz we had to "talk."

He lives out in the country. I'd driven a long way during deadline just to do this so when I saw him heading towards town in his pick-up I blocked the road with my Volvo. He was headed to Burgerville for breakfast with his big hungry friend and their two hungry dogs.

"We have to talk."

"You're in no shape to talk and we're starving."

"We HAVE TO TALK!!!"

He saw I was crazy. Said we'd talk when he got back. So I went to his house and sobbed in his bed until I couldn't sob anymore. Finally he returned.

"So what do you want to talk about?"

"Pleeeeease let me suck your cock. Pleeeeeeease!"

"No, Viva. We're just pals. Pals don't suck each other's cocks."

I started sobbing again until he relented. I was still whimpering, sucking, crying when his friend's little Chihuahua got in on the action. The aptly named Johnson was a four-month-old fireball of unneutered male dog. His tiny two-inch puppy penis was already out and ready to do some damage! He started humping my arm. I shooed him away and concentrated on the blowjob at hand.

One thing led to another and we started fucking—glorious ex-sex, with my tears all over his face and me sucking on every inch of him like a baby that hasn't seen a tit in a while. I was on the bottom, cumming, crying, cumming some more when I realized the wonderful attention being lavished on my breasts was not the work of my ex but of Johnson! He was suckling and nibbling on my nipples with just the right amount of pressure. I shooed him away again, but halfheartedly. This dog was alright!

I climbed on top—cumming, crying, cumming. Breaking up seems to unleash passions that weren't in play before. You want to eat your former lover alive, you're so empty, hurt, jealous, or whatever. Which makes for stellar sex. The best sex ever is often ex-sex.

Anyway, I was really getting my rocks off. When the stars in my head cleared for a moment, I started to wonder how it was that my ex-lover was simultaneously devouring my tongue *and* my asshole. Maybe

he had better skills than I'd given him credit for! Or maybe the guy on ass detail was…JOHNSON!

Friends have told me not to print this one, that PETA will come after me for sure. Like I was intentionally inciting him to take out his tiny tinkler! Whatever! If anyone was victimized, it was I. Sure, I've been known to masturbate my cat (she demands it) and Busta (an *Exotic* office dog who will literally push your hand from his head to his cock's head in one practiced motion), but I would never offer my services to a four-month-old puppy! That's petophilia!

It is time for a new bumper sticker on the Volvo, though:
I ❤ CHIHUAHUAS.

The Dictators
June 2003

My favorite song is on the first record, "Two Tub Man." It's got this great line— "Whatever I want to do I do / Whoever I want to screw I screw!" And years and years before anybody knew it there's a lyric that goes, "I'm just a guy walking down the street / I think Lou Reed is a creep," And "Master Race Rock." "We are members of the Master Race / We don't judge you by your face / First we ask you what you eat / Then we bend down and smell your feet." What is the Master Race? It's drunken teenage louts!
—Richard Meltzer on the Dictators

Long-time pals Richard Meltzer and (Handsome) Richard Manitoba caught up for the first time in over ten years when the Dictators played in Portland last month. Viva sat rapturously in the middle and pressed play on her tape recorder. The rest is history. (For those who don't know, the Dictators are The Greatest Rock 'n' Roll Band of All Time and are from New York City, The Greatest City in the World. As New Yorkers they care passionately about the Yankees, boxing, wrestling, New York, White Castles, pizzerias, etc. Richard Meltzer is The Greatest Rock

Critic of All Time and an ex-New Yorker who still cares about New York stuff but who now lives in Portland and swears he will NEVER GO BACK!)

VIVA: You guys are still around, still touring. Everyone else is dead. What's the secret?

HANDSOME DICK MANITOBA (HDM): We found the Fountain of Youth! We like feeling young. I stopped ravaging my body years ago. Everyone takes care of themselves for general purposes. And more specifically, I always sorta kept myself available to play rock 'n' roll. Whatever job I had, I made sure I could leave it when the rock 'n' roll bell rang, and come back to it to make money.

VIVA: And Handsome is still the handsomest man in rock 'n' roll. What's HIS secret?

HDM: I dunno how to answer that, I'm humble.

MELTZER: You're humble?!?

HDM: Just born that way, I guess. Lucky.

MELTZER: So do you use any kinda hair coloring?

HDM: Me? No. I dye my beard. It's like once a week, I put this stuff on for five minutes. Cuz otherwise it looks all white and I don't wanna look like Jerry Garcia. I'm bald and I walk around all the time like that, but on stage I wear the hats cuz it's a better look. It's like wearing a good shirt. It looks better and I look younger without being bald. If I were James Taylor I guess I wouldn't mind, cuz then I'd be a sensitive singer-songwriter.

VIVA: You've got a lot of hats.

HDM: Yeah, yeah, I got a collection. I've got a custom NY hat with a Jewish star on it. I've got a Bronx hat... I've got all kinds of hats.

VIVA: What's the weirdest hat you've ever worn?

HDM: For my friends from Pennsylvania. They threw me a Philadelphia Phillies hat and I went "photo op!" and put it on for, like, two minutes.

MELTZER: Do you remember—the Dic-heads were always trying to compete for Sandy Pearlman's attention with the Blue Öyster Cult—so when BÖC had their Nazi period, you were doin' your Nazi shtick, too.

HDM: Yeah, but ours was tongue-in-cheek. Pearlman was, like, mesmerized by Nazis.

MELTZER: Don't you remember once, your father was upset with

you and said something like, "Well what about our ancestors?!?" And you picked up a bar of soap and said, "Here's our ancestors!" Remember this? Remember this?

HDM: No. God bless you, Richard, and your memory.

VIVA: On Dictators' *Go Girl Crazy!*, you rhyme "growing up" with "throwing up." Were you listening to a lot of Bruce Springsteen and *Greetings from Asbury Park* at the time?

HDM: No. I think there are only so many words in the English language, and only so many chords, and sometimes in rock 'n' roll they run into each other.

VIVA: What influenced you in the very beginning?

HDM: Our culture influenced us. Which was part music, uh... pussy, gettin' drunk, White Castle hamburgers, and cars.

MELTZER: Have you ever had a White Castle hamburger?

VIVA: Yes.

HDM: You got a good nose. I like your nose.... They've got the greatest thing now at White Castle. The Crave Case. Thirty! In like an attaché case.

VIVA: How many can you eat? You'd have to throw away the bun, wouldn't ya? On your low-carb diet?

HDM: No I don't throw away the bun. Religion is religion, and White Castle is a religious experience.

MELTZER: So d'ya ever eat at Wetson's? Remember Wetson's?

HDM: Yes! I said that *yesterday*, Richard. I said, "Does anyone in this car remember Wetson's?" Errol Wetson was the playboy son of Wetson's. Their specialty was pastrami.

MELTZER: The cheese on Wetson's used to be quite a bit like Velveeta. It was very bad.

VIVA: Any new music that gets you hot and bothered?

HDM: The newest band that I've loved was Nirvana. So that was like twelve or thirteen years ago. To me that was the last great rock band.

MELTZER: They're from this part of the world, you know. Courtney Love used to give blowjobs in the parking lot of the Satyricon before Kurt came along.

HDM: She's from Portland?

MELTZER: She lived here. Her father was a Deadhead! The album *Aoxomoxoa*—she's on the cover. Wanna see what I've got in my pocket here?

HDM: OK. [Meltzer pulls out a pocket watch.] You've got a Dead watch. Really! Wow. That's cool.

VIVA: Sexiest song of all time?

HDM: It's gotta be some black soul singer. I don't know...Al Green? It's gotta have that slow Al Jackson-Booker T., Otis Redding slow, sexy...

VIVA: Sexiest record of all time?

HDM: What's the difference between a record and a song?

MELTZER: What's the sexiest cassette?

HDM: What's the sexiest 8-track?

VIVA: Alright, alright. Who's the sexiest singer?

MELTZER: Portland has 8-track collectors.

HDM: Shakira.

MELTZER: Portland has a lot of people who collect 8-tracks. They go to the Goodwill every week, see if something new shows up...

HDM: Or Ann-Margret.

VIVA: Sexiest thing about Debbie Harry?

HDM: Her face.

VIVA: Sexiest thing about Joey Ramone?

HDM: His voice.

VIVA: Sexiest thing about KISS?

HDM: Nothing.

VIVA: Sexiest thing about NYC?

HDM: The fresh mozzarella that I get around the corner at Rizzo's. Sexy. Mozzarella is sexy. It's just a glob of white that they bring up from the basement. And as you press it or cut a knife into it milk spurts out.

VIVA: Oooo! Lovely! Thank you. What's sexy about having a kid?

HDM: I don't know if it's sexy—having a kid. It's got everything else, but I don't think it's sexy.

VIVA: Sexiest Stones song?

HDM: When I was, like, eleven years old, "Satisfaction" was my favorite song ever. And I like all those mid-sixties singles like "Mother's Little Helper" and "Get Off My Cloud" and "Paint It, Black." To me they were perfect rock 'n' roll songs. Hot!

MELTZER: I hear that Dylan is playing "Brown Sugar" as part of his set now.

VIVA: Do you have a favorite Dylan song?

HDM: Yeah. I heard it on the radio yesterday. FORTY YEARS

after a song comes out I still get chills and I still get overwhelming feelings when I hear "The Times They Are A-Changin'." It's as heavy as the heaviest song ever written. I get a physical reaction to that song. To me that's a song that changed the world.

MELTZER: I think the Byrds' version is even better.

HDM: If I was listening to two hours of music and you said, *Well, you can listen to two hours of the Byrds or two hours of Dylan*, I'd listen to two hours of the Byrds. But the Byrds didn't change the world. Bob Dylan did.

VIVA: I love Gram Parsons.

HDM: I love Gram Parsons. I love the Byrds. I LOVE the sound of Roger McGuinn's voice, and I LOVE the sound of his Rickenbacker.

[Both Richards start singing "The Times They Are A-Changin'."]

HDM: That was just so powerful. It was like one of those times, like when Elvis came out and it was blown from zero to one. Three acts turned the world upside down—not that they're my favorites!—but Elvis Presley, Bob Dylan, and the Beatles.

VIVA: Who are your three favorites?

HDM: The Stones, the Beatles, and… What was your band called? Vom. [Vom is the proto-Angry Samoans band that Meltzer founded.]

MELTZER: What about the Doors?

HDM: No way. Not even close. He was an L.A. guy! No. The Stones, the Beatles, and Brian Wilson. I love Brian Wilson. That's one body of music I could listen to for more continuous hours without taking it off than any other body of music. I could listen to the whole box set and do my chores around the house and not get tired.

VIVA: Sexiest wrestler of all time?

HDM: Freddie Blassie. Check out this magazine. This is so amazing. Look at this photo! The caption says, "Women really go for me." Now sit down. I'm gonna read one paragraph to you. But you have to imagine it in Blassie's voice. Ready? Alright. "About Antonino Rocca."

"There was another thing about Rocca that made him one of the most intriguing men in the business. A detail I figure that most fans didn't know. He had the biggest cock most of the boys had ever seen. You should have heard them go on and on about it. They'd hold their hands apart and talk about the length. They'd cup their fingers together and describe the thickness. Then they'd talk about the sight of Rocca lying back on a bench in the locker room with the head of his dick

resting in the middle of his chest. But you can rest assured that Freddie Blassie never took part in these lively exchanges. I talked about wrestling and Cadillacs, women and making money. I was never interested in cocks."

That's genius! Like he doesn't even say, "I talked about wrestling, cars, girls, and making money. He goes, "wrestling...*Cadillacs*." That's like saying White Castles instead of food or hamburgers.

VIVA: What color panties are you wearing and how long have you been wearing them?

HDM: Black, two-button Calvin's. HDM DON'T WEAR NO PANTIES!

VIVA: Would you rather go bowhunting with Ted Nugent, or drink 'til ya puke with Lemmy Kilmister?

HDM: Drink Yoo-hoo 'til I puke with LEMMY! [Suddenly watching the TV very intently.] Goddamnit where's the score I want? Boston won. Shit! Fuck!

MELTZER: So I really think that Clemens has the stink of the Red Sox on him.

HDM: Stink of the Red Sox... I'm not a huge fan, but he wears the pinstripes, so I like him. Sorry, Richard. Ha ha ha. The stink of the Red Sox.

Merry Fucking Christmas, Assholes (or Why Not to Date Viva Las Vegas)
December 2003

As most of you know, the Las Vegases hail from Minnesota. Most of you probably are also familiar with the Coen brothers and Garrison Keillor, and so are aware of our long-winded, much-ado-about-nothing oral tradition. But what you probably didn't know is that this tradition—this need to ramble on for hours about the weather and other petty grievances that make up life—reaches its finest form during the holidays when the Christmas letters hit the streets.

I myself was a bit in the dark about this. I've been on the road for a good thirteen years now, but whenever I'm home sweet home I've little better to do than sift through old mail and photos and keep up on the births, deaths, illnesses, marriages, divorces, who's gay, who's straight.... I was doing precisely this when I stumbled across Cousin Donna's annual Christmas letter.

Or should I say CHRISTMAS EPIC. The thing was eight pages in length. Donna went into careful detail about the most mundane things, covering them on a month-by-month basis. There was her brother Duane's foot surgery and layoff, the several trips to the casino, where the bus stopped en route to the casino, what kinds of pies were served at the truck stops, what productions were seen at the dinner theater, and a recipe for Rhubarb Sauce Pudding she created: "Rhubarb, brown sugar, Cherry Coke (or Coke Classic) and dry tapioca. MMM-MMMM Good Stuff." It was pure genius. American beauty. Totally Minnesotan. ("Minn-eh-SOOHH-tin")

So, in honor of Cousin Donna Las Vegas, I thought I'd share my year with you.

JANUARY: Started out rainy like it always does. I made resolutions to (1) imagine I was Catherine Deneuve every day (this later changed to Brigitte Bardot), (2) write a book, and (3) move back to New York. We had a Magic Gardens sleepover where we smoked lots of pot, drank a bunch of wine, and ate fondue (cheese *and* chocolate), watched *Sixteen Candles*, *The Breakfast Club*, and *Fast Times at Ridgemont High*, and talked about cock. I tried to interview Hank Williams III three times, but he was always sick. I was supposed to go to NYC, but at the last minute found out my favorite band ever, ZEN GUERRILLA, was playing in Portland while I would be in NYC, and playing NYC while I was in Portland. Had to change my flight. Ashauna died in an auto accident on January second and it was really sad around the office for a while.

FEBRUARY: Started off RIGHT in NYC. I saw Zen Guerrilla at CBGB and bumped into BRETT FALCON there. He is sooooo dreamy. He makes the slippery stairs to the CBGB shitters seem like the most romantic place in the world. I luuuuv you, Brett Falcon! I went to see Omar at Lucky Strike and he wouldn't talk to me. What a bitch. So

I drank my manhattan alone, smoked my last few legal cigarettes in an NYC bar, and wrote many dismal poems while he whispered to everyone about me. I got a shirt made that said I ♥ ANGELO.

We broke up a week later, got back together, and then broke up again the following week cuz he said he didn't believe that stripping was art. God what was I doing with him?!?

I chipped my front tooth at a performance of my acting class and tried to convince myself it was cool. Nobody died.

MARCH: I quit acting class, realizing I have absolutely no respect for actors. None! Zip! They want "honesty" in their work. Ha, ha, very funny! They should try STRIPPING.

March SUCKED. I had dinner at Ripe on the first (the owner is dreamy!) and then went by His Bar afterwards. He had locked himself in his car to avoid me and didn't answer my phone calls, even though I called twice every minute for half an hour. He was pissed that I wrote my cock column. Whatever! Who does he think he is? I've been writing silly stuff like this for strippers for five years! He said it wasn't classy. Whatever! He PEES ON PEOPLE at his bar! I was so pissed. Especially because we were supposed to have a nice Seattle trip the next day.

He broke up with me for two weeks, thoroughly emasculated that I should refer to some "camel jockey" as the "best" lover I'd ever had. Eventually he took me back, just in time to go to His Bar to chain-smoke and play pinball and freak out the night Paul Stojanovich died.

Paul was a creator of *COPS* and other reality shows. He was a very dear friend. He fell off a cliff at the Oregon Coast. I was in shock for a couple of weeks and then really came unglued.

APRIL: HE took me to Vegas. I fell in love with it. It is the weirdest, most bizarre place on Earth. Where else do folks throw billions of dollars around to out-weird each other? Pure genius. Shows that America can still crack a joke, even if it doesn't get the punch line. We stayed in a fucking pyramid that beams the strongest light on Earth into outer space for no reason other than to boast about it. So cool.

The best thing was the cathedral on The Strip that has modernist stained glass by two Polish sisters depicting the Stations of the Cross. One of the panels shows old casinos like the Stardust and the Frontier, disgorging their gamblers to the great casino in the sky.

Easter I went to church like a good preacher's daughter. I saw this gal I knew from the downtown scene. She looked completely possessed. A week later her boyfriend OD'd. That put a heavy pall on my Eastside hangout and was sad sad sad. Cheers, Cherry Sprout.

MAY: Nobody died. My guy and I celebrated our first anniversary, after which I broke up with him again. We got back together a couple days later cuz I love him and always start to miss him.

JUNE: I broke up with him AGAIN! We had a nice coffee date as was our habit during which he said that it was impossible for a guy to want to fuck the same girl after three months. I endure most of his retarded and humiliating opinions, but after this one I just looked at him coldly and kissed him goodbye. He didn't realize I'd dumped him until he heard through the grapevine that my ex-boyfriend was driving me to the airport at 5 AM the next day. For some inexplicable reason he was furious with me. For giving him what he wanted! Once again he said I had "absolutely zero class." Once again let me state for the record that HE PEES ON PEOPLE at his bar.

I went to NYC. It rained every day and was very cold. I missed Portland, missed my girlfriends, missed Sauvie Island. Nick Tosches cooked me dinner—wonderful pasta with fresh salmon and French sardines and plenty of port—and we chain-smoked and discussed how much New York sucked for three days. He said, "Why don't you move to Paris, baby doll?" That or Vietnam, Cambodia, Laos—wherever the last opium den is.

The Dictators came to town and I got to hang out with Richard "I Love New Yawk" Manitoba and Richard "I'll Never Go Back There Again" Meltzer. Heaven, I tell you! Heaven!

Nobody died.

JULY: My guy and I were broken up and back together twice in July. I starred in an indie short. Three friends died.

Adam Cox, Matthew Fitzgerald, and Jeremy Gage were killed when their van rolled outside of Eugene. They were members of Portland's best band, the Exploding Hearts. The subsequent memorials were packed full of punk rockers wearing their nicest pink clothes in tribute to this group that boasted they were "100% POP," embraced a

hot pink and yellow color scheme on their record and website, and wore WHITE JEANS to the Satyricon.

Oh my God, this one broke my heart good. I sobered up from my intoxicating relationship and decided it should really be O-V-E-R. Like some barfly said to me, "Life's too short to be with someone who doesn't adore you."

AUGUST: I went home to Minnesota and South Dakota to see the Las Vegas clan. It was good. I performed at Bumbershoot in Seattle with Andrei Codrescu and it was good. Rain Stormm had her second baby boy in Nashville. Nobody died.

SEPTEMBER: Went back to Vegas for a final fling with the boy toy.

Fell hard for the La Concha gift shop and Peppermill bar. Also got to meet DJ Harlock's mom, which was exactly like you'd expect it to be.

One week later I dumped HIM for good. Thank God. He was killing me. Everyone at *Exotic* and the Magic made bets on when we'd get back together. Some of the bets are on 'til Thanksgiving. Whaddya say, Mr. Classy Pants?

Nobody died.

OCTOBER: Back on the all-toast diet, which I always do when I'm single. Even opening a can is too challenging. Here's my favorite slice of toast:

1. You take the really expensive Women's Bread (made in Minnesota!) from Whole Foods or Wild Oats cuz it's yeast-free, sugar-free, and packed with soy protein and flax and other life-sustaining stuff.
2. Toast this bread and then put almond butter on it. The best is the freshly ground stuff from the Fred Meyer nutrition section.
3. Then you put honey or whatever on it. This will keep you going indefinitely until some boy takes you out for food again.

I went to L.A. with Lucy Fur. We made fun of everyone for not being as cool as we were. Lucy Fur hearts L.A., and I finally started to see why: it is weirder than Las Vegas.

Got back to hear that Morgan died. Seriously fucked. Who figured him to be a horse guy? Not me. The magazine was filled with his stuff. His friends kept coming by the Magic. I was dancing to the Exploding

Hearts. So many of us were still alive but all we could think about was these guys who were dead.

I did not go to New York. I did not want to. I was scheduled to go there to find a job and an apartment but I postponed my flight indefinitely. I started looking for a house here. Man I'm on a lot of Zoloft. Sometimes I feel like I owe it to my dead friends to hang around here, to keep their memories alive. I'm starting to realize that I owe it to my alive friends, too.

NOVEMBER: Nobody's died—yet. My best friend from high school had a girl, her fourth kid. My most-recent ex seems to miss berating and degrading me and so calls to tell me I have no fucking class and shows up at parties I'm hosting. I went to His Bar to celebrate my other ex's last bartending shift ever and got eighty-sixed. "What did you expect?" friends asked. As if I care.

I saw the new Best Band in Portland at Kelly's Olympian, of all places. Diamond Tuck & the Privates RULE! They are carrying the torch. Jedediah—Be Mine.

DECEMBER: My brother comes to town to kick ex-boyfriend ass. I spend five hundred dollars on Christmas tickets to Duluth, a.k.a. the North Pole. The dentist says my teeth are perfect. Everything is gonna be okay. Frank says Zen Guerrilla will be here in the New Year.

Seeing as it's time for us all to make resolutions, may I suggest:

1. Hire Aristai to clean your house. You can't do better than hire a drag queen houseboy. He gives great advice, rearranges stuff stylishly, is gossip central, and will totally improve the quality of your life. He is the best. Call *Exotic* for details.
2. More sex with fewer people.
3. Less sugar, more cats!
4. DON'T DIE.

Peace on Earth, etc.
—Viva Las Vegas

Dee Dee Ramone
January 2004

Saw this rather unremarkable yet life-changing documentary about Dee Dee Ramone last month. *Hey is Dee Dee Home* was shot by Lech Kowalski over two decades, but most of the footage was filmed shortly before Dee Dee OD'd in June 2002 (which, I must point out, is a palindrome and therefore an IRRESISTIBLE FATE: D.D.OD'D).

The film is basically a long interview—off-the-cuff, unscripted, and illustrated with cute clips of Dee Dee over the years. It paints a very human portrait of this dumb, goofy kid who somehow became a seminal influence on our culture.

It's an abstract expressionist bit—big brush strokes in four colors. The colors are Connie, Vera, Johnny Thunders, and heroin. The Ramones and the success of the Ramones seemed to matter very little to this bowl cut-sporting bad boy. He loved his guitars, he loved music, but the story of his life as it played on the four-disc changer in his head went heroin-Thunders-Vera-Connie. The girls he loved and lived with were tattooed on his skin, heart, soul. So was his rivalry with Johnny Thunders, who ripped off Dee Dee's big hit "Chinese Rock" (and half a dozen or so of his girlfriends). In the end it was the love of his life—heroin—that killed him.

I've yet to read Dee Dee's autobiography, *Lobotomy*. I know relatively little of the man—just lots of firsthand stories that he was a dumb junkie asshole. But the way this film distilled his life to four words kinda got to me.

Life is so short—two chicks, one stolen song, and half a million bags of dope and it's over. That's it! If you were to tell your life story tomorrow, what would you say? Cash? Career? Cats? Hobbies? Habits? Heartbreaks? If someone made a film of your life and you had to pick four words, what would they be?

It's strange to me to live in a society where the Ramones, where Punk Rock, where Fuck You are seminal. Look around. Our culture has been totally punk-rockified. I've got fancy skull-and-crossbones tissues. I saw a Paul Frank skull-and-crossbones sweatshirt on a baby. The Queen of England probably wears studded cuffs and midriff-

baring t-shirts with safety pins. Fuck You, I mean Punk Rock, is a language now, a religion. But to Dee Dee Ramone it was a life. A shitty, boring, hard, fucked, funny, short life.

Life-is-short is a real tired cliché. It makes me panic with its implication that time is running out, that I'll never get "it" all done. After I saw *Hey is Dee Dee Home* I thought seriously about getting "Connie" and "Vera" tattooed on me, an homage to this fuck-up as much as a reminder to fuckin' fuck up more, to fuckin' live!

But last night folkie nightingale Martha Wainwright fixed my wagon. Martha, sister of Rufus, said, "Life is sooo looong." Try saying that. Then remember that it's Tuesday, January 13, or whatever day it is, and relax and enjoy it.

Conservatism As a Personality Disorder
March 2004

I've been trying not to read the paper for three years now, ever since Bush-the-sequel started, but I couldn't help but notice that gay marriage has had big headlines lately. And that Bush 2, or "Shrub," has allotted one and a half billion to go to war to fight it.

This is ridiculous! Who cares if gay people marry? Who cares if they cross the street? I think we've already established that being gay is A-OK legally, so if marriage is a legal agreement, gay people should get to do it if they so desire. If you're personally not okay with it, don't marry someone gay. Sometimes obese adults wear Disney sweatshirts and it really bugs me. Still they get to cross the street, get married, vote.

"Sixty-five percent of Americans feel that homosexuals should have equal rights in the workplace. However, thirty-eight percent feel that homosexuals should be allowed to marry. That's down one percent from last week."

Who cares? And why do they even think it's okay to ask those questions? Here's what they should ask:

"How many of you feel that the Christian Right should be banned from any and all public forums?" or "How many of you feel that President Bush should be ritually axe-murdered to appease the international community?"

I bet the stats would be approximately the same.

Shrub and Co. say they're defending the American family. But even their homo-foe statistical formulae conclude that gay couples make as good or better parents. In fact, gay partners are more likely to have a stay-at-home parent than hetero marrieds.

Shrub and the Righteous Right say marriage is a holy union blessed by a homophobic God. Well, then marriages shouldn't be conducted at city halls or carry so much weight legally. Ever heard of separation of church and state?

Shrub and the State of California define marriage as a union between a man and a woman. But, uh, what is a man? What is a woman? What is a homosexual? Take a swim in the murky waters of gender studies for half an hour, Bush buddy, and it'll shrink your cocksure sure as shit. For instance: can a homosexual woman trapped in a man's body marry a lesbian? They got man and woman PARTS... Or what about a postoperative transsexual marrying his (now her) longtime boyfriend? Is that okay? Maybe we should just institute a *don't ask, don't tell* policy for marriage like we do in the military. No one needs to know who's a boy or who's a girl under that gown!

What does marriage mean anymore anyway, when over fifty percent of marriages dissolve before the death-do-us-part part? Europe has recently come up with marriage lite: civil solidarity pacts and registered partnerships which allow couples, gay and straight, to proclaim their commitment to each other and maintain all the legal benefits of marriage, but without the freakiness of "forever." Scandinavia has all but done away with marriage, and most children are born out of wedlock. Many feel this is a positive trend, sparked by women's lib and the decreased influence of the church. But conservative presses blame gays being allowed to marry for lessening the appeal of marriage. According to the *Weekly Standard*, this takes away marriage's romance and "mystique," and should therefore be avoided at all costs. Talk about fuzzy logic.

Here's some logic I like. My army brother's friend's father, a PhD in

psychology, is writing a book on conservatism as a personality disorder. Hee hee. That's what I like to see. Here's hoping it's a bestseller. Conservatism as a Personality Disorder.

April Kicks Ass
April 2004

April kicks ass? Well, she kicked mine!

Richard Meltzer says rock 'n' roll is a fight waiting to happen. I say, "Hey, I said that!" Richard Meltzer says what's a nice girl like me want to be hanging out at rock shows for? I say, "Nice girl?"

You all seem to have me pegged as a "nice" Midwestern preacher's daughter walking on the wild side. Well, I am, but preachers' daughters are notorious rabble-rousers, ya know. And just cuz I'm "smart" and got this little giggly, high-pitched Marilyn voice doesn't mean that inside I'm not Mike fucking Tyson. Geez.

I got beat up again. That's, what, five times in five months? Yup. Officer Friendly calls me his little punching bag friend. Hippie stripper says I'm just trying to be closer to an abusive ex-boyfriend. I say people just keep pissing me off!

This time I wound up in the emergency room. Drove myself there in lieu of seeing the Melvins post-Mudhoney to get my lip stitched up and my grossly swollen face X-rayed. Some smelly little skater-chick beat the crap out of me when I asked her sternly to stop pushing her ass into my hipbone over and over again. Folks say I should learn how to street fight, but I don't hit chicks. Ever. Ex-boyfriends I'll work over now and then, but never chicks.

So I've been rockin' this black eye for ten days now. It is really, really black. The lid is ash black like superfab smoky eyeliner and the rest is purple. Blondie says, "It looks like Mac! It's gorgeous!" Most people say nothing. You can tell they want to ask, but I act as if nothing is horribly wrong with my face and they respond in kind. Until I walk down lower West Burnside.

"Holy shit, gurl, you betta find that motha-fuckah and kick his motha-fuckin' ass! Gurl!"

The bums all wanna know how I got it. Usually I like to say, "I got beat up by a chick!!!" Like, how-humiliating-is-that? Mexicans do drive-bys and point out the obvious: "Wow, you got knocked out!" The yuppies turn and stare. I think they want me to cover it up. But why should I? I got nothing to hide. Hiding a black eye indicates someone inflicted humiliation on you. Not me! I was, uh, proud, sorta. Especially when I heard that it was Mudhoney who got the rumor mill churning, telling Mike H. that I kicked the crap out of *her*. Plus it really is quite lovely. The purple brings out the green in my eyes, and looks spectacular if I wear a little lavender sweater. I wear pigtails often, and folks say I look like a Jim Goad cover girl. One night I wore a prom dress and classy boots and a silky black bob wig. And a black eye. I'm having a motherfucking blast. I'm gonna miss it when it's gone. It's a great conversation starter, too, and Lord knows I love a great conversation.

At work all I have to do is put industrial-strength foundation on the bottom (that Revlon ColorStay shit is like plastic) and then match my left eye to my right with various purple and black shadows. If I feel I need to impress a regular with my Mike Tyson-ness, I point out that one eye is naturally TOTALLY FUCKED. The girls call me Scarface and Bruiser and I blush like I'm twelve.

Maybe this is taking my tomboy thing too far. I always dreamed of winning the Heisman Trophy, not the trophy husband. This bruiser Viva was always just under my skin. You can see her now, melting down the right side of my face.

Of course violence is not cool and if someone you love is beating the shit out of you it eviscerates you and never ever heals. But I don't love this little skater-tramp—whose name, by the way, is April—and rock 'n' roll is a fight waiting to happen. I haven't been in a rock 'n' roll fight since Zen Guerrilla in 1998. Feels like an auspicious time to announce the return to the stage this month of Portland's bruiser band par excellence, COCO COBRA AND THE KILLERS, playing with the supergreat Electric Six on April 27 at Dante's.

You wanna fight?

Band Sluts Do Bellingham
June 2004

It's been a long while since I felt like being a band slut, the best feeling in the world.

I fell hard for Diamond Tuck & the Privates back in November. They snapped me out of a funk with their first song, a mix of heavy metal, glam rock, Oregon pride, and total hotness. An eight-piece band carefully culled from the lifers of the Portland rock scene, these guys and gals know how to throw a show.

Captain Diamond is 6' 2" and covered with tattoos. As the leader of the pack, he makes the call on whether the boys wear pink or white denim and coordinates eye makeup, too. His best outfit is sweat and man was he wearing it that night.

Kelly's Olympian was packed. The band barely fit on the makeshift stage. Midway through the show Diamond waded out into the crowd, made out with a lucky slut and then mounted the bar, preaching a chorus of sexxxed up YEAHS to adoring worshippers, pouring a drink down his smokin' hot chest and reclining in his best Burt Reynolds pose. The band and the backup singers broke it down to a whisper while Diamond told all us pretty ladies just what was in store for us. The volume came back up and the whole ensemble rocked out—complete with choreography—'til every last panty was wet and every t-shirt was sold. I went home shaking my head in disbelief. I've known this Diamond fellow for years. I've seen him in a hundred rock bands. But oh-my-goodness I had no idea…

I woke up the next AM still wondering who was the lucky slut he made out with on the floor. I vowed to kill her.

Two months later the band was appearing at Slabtown with another Portland all-star band, Starantula. I'd seen Starantula four years before and thought I knew what they were all about. I was wrong. In that time they'd changed from a lounge-punk novelty act to a blistering four-piece RAWK band. Think the Jimi Hendrix Experience fronted by Jim Belushi dressed as John Travolta. You cannot NOT dance to Starantula.

Diamond Tuck played first. The estrogen in the room was so thick

that I decided to let him alone. I made love to my tequila and danced my ass off instead. When Starantula took the stage I accidentally fell in LUV with Kelly Gator—Fireballs of Freedom lead singer and axe slinger—right in front of his girlfriend! My eyes were crossing and she could tell. She glared at me through the smoky, sweaty haze and I conciliatorily made out with seven people: two chicks, two drummers, two strangers, and DIAMOND, who very politely asked, "Viva, will you come make out with me in the bathroom?" We sucked face on the floor while his guitar player Private Mike took a piss right over us.

The morning after, I was still in love. I was shocked by my lingering lust and went to the clubhouse to tell Blondie. Blondie said, "That's not love. That's rock 'n' roll." Duh.

Blondie had been celibate for, like, weeks. She was in that lipstick-buying, cat-petting phase of the Men Suck continuum. It was getting harder and harder to get her to go out. Then I got beat up and everybody except the men I was fucking felt sorry for me. Blondie was even willing to be my wing-woman. I took her to 72nd Avenue where the band parties and made her make out with Private Mike.

Diamond and Private showed us a real bitchin' time, taking us to rad bars east of 82nd and finally to drummer boy House Arrest Dan's house where Blondie danced to Hall & Oates in her legwarmers and Diamond made out with me in spite of the stitches in my swollen, bloody lip. One short week later we were on the road to Bellingham, following Diamond Tuck & the Privates on their tour of the Northwest with Starantula.

Bellingham ROCKS. It's got something of the energy and excitement of the Satyricon scene in its much-storied heyday. Lots of little rock 'n' roll bars are lined up on State Street. Nearby Horseshoe Café and Tavern has a twenty-four-hour breakfast and a groovy cowboy pull-tab lounge. Blondie and I had biscuits & gravy there for dinner and then got slutty in the bathroom after the long greasy drive. Blondie put on her makeup in the midst of a full-on dyke battle, sometime-lovebirds tearing each other apart but still not immune to Blondie's considerable charms. Blondie is every dyke's wet dream. I slipped out of my tight jeans and lavender black-eye-accenting sweater into fishnets, short white denim skirt (Diamond had informed me that the "theme" of the evening was white denim), and red, knee-high alligator boots and we

ran to the rock club. The bands and their bitches were all there and I instantly started to swoon, but Blondie needed vodka toot sweet.

We wandered the streets looking for something other than a tavern and wound up at the Factory—another supercool Satyricon-y bar with, thank God, liquor. Blondie downed three vodkas with Red Bull in quick succession and I medicated with two. Back at the 3B, I flirted and twinkled and didn't notice that Blondie looked like a beautiful schizophrenic about to throw herself out a window. I got her some water and took her to the bathroom for a nice puke photo shoot. Soon Blondie felt blonde again. "Glad I got that over with!" she chirped.

Diamond and Co. took the stage and took the TOWN. The locals gawked in shock while we Portlanders danced and screamed and made out. The local paper was there to document it all, fell in love with Diamond, and took notes for a front-page feature in the *Bellingham Daily*. These guys are IT, man!

Diamond was wearing his pink leather captain hat, a big black monkey fur jacket, a tight white t-shirt, and tight white Levi's. Private Mike had on white denim trousers AND matching jacket, his white private hat and aviator specs. And his Flying V, which he played as masterfully as he'd been playin' Blondie. House Arrest Dan and bass player Private Andy are the lookers of the band and are deadly. What kinda girl doesn't fall for the rhythm section straight off anyway? They wore head-to-toe white denim, too. Then there was THE WIZARD, Greg Gallant, wielding a Flying V, black handlebar moustache and long black Ozzy hair. He's all Black Sabbath at night, but during the day is your average pot-smoking Converse-wearing Northwestern cutie. Finally, the pistol-hot Hidden Valley Singers: Lucynda Beth, who is, according to Diamond, "More woman than most men can handle," Heather from DOTS, who is blonde and has hamburgers tattooed on her sternum and wears groovy polyester pantsuits, and beautiful, honey-voiced Cameron, a.k.a. "Cam-Shaft," the world-famous hula-hoop boy. Cam is tattooed and skinny and uses the ladies room so you can ogle him in the light. He plays a mean tambourine.

Blondie was in fine form by now and joined the rest of us sluts on the floor, shakin' it hard to Starantula—the best dance band on the West Coast. Starantula's got it and there ain't no doubt about it. Every girl from every walk of life jumped out of her seat to swoon and shimmy

and sing along to their rockin' cover of "Fooled Around and Fell in Love." Cam hula-hooped.

The after-party was at the hotel room. Everyone had been on the road for days and was smelly and sleepy. Diamond lent me his chest as a pillow and covered me with his monkey fur. Private Mike and Blondie curled up in the alcove under the vanity mirror after raping each other for hours. Everyone else watched TV.

The next day we had breakfast with the whole motherfucking band. The boys and girls trickled in—each hotter than a jar of Hot Mamas. Me 'n' Blondie giggled and cuddled, feeling like the luckiest girls in the whole world. What band sluts get to stay the night and then stay for breakfast?!? We felt just like My Little Ponies, smeared mascara and all.

After breakfast we headed to the Murder Bar, so-called because Ted Bundy, the Green River Killer and the DC Snipers all partied there. Everyone ordered White Russians. I took mine black. Local bar slut got excited about my black eye. Said she just got the shit beat out of her by her old man but the cops took HER in for four nights. In fact she was fresh outta jail that morning. I admired her ring. She guessed that we were rock 'n' rollers. Private Mike told her the band was Iron Maiden and that we were off to Japan in eight hours. Told her Blondie was his wife of seven years. Blondie melted all over the bar like a soft-serve sundae smothered in hot caramel.

We had two more rounds at the Murder Bar and then stumbled out into the late-winter sun. It was time to go home. Blondie and I rubbed noses with our band boys and sped away in the Volvo, reliving every slutty detail over the dreamlike five-hour drive home. We knew that Diamond Tuck & the Privates had more band sluts than any band in the world. But man don't it feel goood to be back in the saddle? Huh, Blondie?

Money 101
September 2004

The best things in life are free, but you can give them to the birds and bees.
I want money. That's what I want.
 —Stones, Supremes, Beatles, Flying Lizards, etc.

I started stripping for the money. I had college loans that were suffocating me, and I wanted them gone. In six months. While the rest of my college pals shopped for suits and resumé paper, I looked longingly at the mysterious bars and fetish wear emporiums on the wrong side of the street. Soon they were working for poverty wages at non-governmental organizations and I was getting naked for Hundred Dollar Dave.

I bet I made twice what they did. But at the end of the month, I was always broke. For four years, I worried about making my rent at the end of the month and it stressed the fuck out of me. Then I got a little checkbook-sized file thingy for stashing my cash.

So many strippers I know are perpetually broke. It's not like they have mega coke habits or even outrageous addictions to lipsticks and shoes. They just spend it when they got it, and don't worry about it until they don't. Suddenly it's September 30 and you've got two more shifts to get your shit together by the fifth. That's no fun.

But it's easy to change this. Get a checkbook-sized file thingy and read on!

MONEY 101

1. Have a goal. I wanted to go to Africa again and see Paris before the world ended. I needed a travel fund. But you can have anything! A buy-a-house fund, a hire-a-hitman-to-kill-the-ex fund, a miniature Yorkshire terrier fund…but it has to be something you really want, not just need. A fun fund. Put twenty bucks in this fund rain or shine. Whether you make five hundred dollars or forty-nine.

2. Figure out your monthly bills. Say your rent is six hundred dollars, your phone is fifty, your utilities are one hundred fifty. You need eight hundred dollars. That's two hundred a week. That's a lot. Are you working four shifts a week? Put fifty bucks in a bills fund after every shift.

3. a. Credit cards are evil. Cut them up.
 b. How much credit card debt do you have? Sock away two twenties every shift 'til it's gone. I paid off thirty thousand dollars by doing this.

 NOTE: Divvying up your big take on Day One sucks as you see three hundred dollars quickly shrink to a little pile of grocery money. But on Days Three and Four, when you suddenly have one-third of your rent and money for your Visa bill, you start to get into it. The accumulation of dollars slowly becomes more fun than spending money you don't really have.

4. ADVANCED TECHNIQUE: Once you've mastered the basics, you can get funky with it. Got a haircut coming up? Throw twenty bucks into a beauty fund. Dude's birthday 'round the corner? Throw twenty into a birthday fund. Strippers survive solely on cash. It's waaaay too easy to think the five hundred dollars you scored on Friday is all fun money. Hey, most of it is! But if you get used to tucking away the first hundred or hundred-and-a-half, your fun money is a lot more fun.

5. WAY ADVANCED TECHNIQUE: It usually only occurs to lifer strippers towards the end of their careers that most people have retirement funds. The Man they work for knows that eventually their knees and hips and brains will wither and they'll be useless but still have rent/mortgages/phone bills. Ever heard of a Roth IRA? It's for chicks like you! You can put up to three thousand dollars into a Roth every year. They don't care where it comes from—could be your grandma, your daddy, your sugardaddy. You get a great interest rate, and the interest you earn is tax-free.

Most strippers I know don't think much past next week. But when you realize that stripping is the THE BEST JOB YOU WILL EVER HAVE, where you make the most money in the least amount of time, you will start to make adjustments for the future. Start simply. You tip-

out ten percent or more to bar staff, right? Well, pay yourself ten percent, too. That money goes straight to the bank. This gets fun after a year or so, when all of a sudden you've amassed five thousand dollars. Then you can think of other smart-ass investment opportunities, like buying a house or your very own lingerie modeling studio, or fucking around in a stupid punk band like me. Yee ha!

Smelly Sock Guy Speaks!
August 2003

Smelly Sock Guy has been a downtown legend for several years now. When I first met him at the rack at Magic Gardens he was quite timid and easily pleased with frilly little white socks worn onstage. Now he's in the big leagues, buying table dance after table dance, inhaling deeply the aroma of your stinkiest socks and requesting you stand on his chest and exert as much weight as possible—for twenty-bucks-plus a song. He also gives absolutely fabulous foot rubs, and pays twenty bucks a song for those, too!!!

Stripping is a hard job. Lovely stripper feet really start to hurt after sweating several hours in seven-inch heels. They start to stink, too. I can think of no better treat during a grueling five-hour shift than to have a visit from Smelly Sock Guy, who asks me to sit down, take off my shoes, have a drink, let him rub my feet, and then try to choke the shit out of him!!! Really it's lots of fun. And quite a turn-on for me, too. Not to mention extremely profitable. Smelly Sock Guy is very generous, and to accept three hundred dollars from him for foot worship sometimes seems like highway robbery. But of course we are all happy to oblige.

Viva: Hello, Smelly Sock Guy! How are you? Has summer got you down, now that all the gals are going sockless in sandals?

Smelly Sock Guy: Summer is a double-edged sword. The flip-flop craze has gotten way out of hand and it seems like everyone AND their mother are wearing the little bastards. But then summer is a time

when girls who do wear socks take off their shoes. It is very sexy to see a girl in public with socks on and her shoes off. Businesswomen also tend to dangle or remove their shoes outside more often in the heat.

Viva: Are you into bare feet as well as stockinged feet, as long as they smell?

SSG: I am into cotton socks and to some extent nylons. Bare feet can be attractive (nice polish, shapely feet, etc.); I just do not find any sexual attraction in them. Now socks, that's another story. If there were ten supermodels in bikinis and high heels walking around next to a punk rock girl with her boots kicked off, I would be staring at the boot girl's socks.

Viva: What exactly are you into? Is it the smell? Or is it feet? Or is it SOCKS?

SSG: I am into smelling women's socks and watching women smell each other's socks. Nylons are okay, but thick cotton socks are the best. I have also recently (within the last year) gotten into trampling. Trampling is where I lay on my back and the girl stands on my chest (in socks). The air is pressed out of my lungs giving a real light-headed feeling, then the girl puts her smelly socks over my nose. Unbelievable!

Viva: What if a gal's wearing socks onstage that aren't stinky, like Lucy Fur at Mary's Club, whose trademark is a variety of nifty knee-highs?

SSG: I love the look, but the fetish is the smell. Although I always tip the girls in socks better.

Viva: If you found a girl's stinky sock on the floor, would you pick it up and sniff it ecstatically? Or must she be wearing it?

SSG: Depends. If I knew who the sock came from and I would be attracted to her then I would smell it. But I would not go after just any old sock on the ground. I have bought socks from dancers and girls on the street before. If the socks smell good, I take them home and my wife will wear them for me during sex.

Viva: When and how did your fascination with stinky socks begin?

SSG: I actually spent some time in therapy for this as a child and I have a good idea.

When I was a baby I used to pull on my hair. My parents put socks on my hands to prevent this and get me to stop crying. During this period my parents reported that I would often rub myself with my sock-covered hands.

When I was ten years old, I remember having a crush on a fourteen-year-old girl named Stacy D. I would follow her around and carry her books and stuff. She was also my first kiss. We used to go to the back stairs at school and she would take off her shoes and have me smell her socks. Her friends would be there and they would laugh and tease me.

Growing up I would masturbate with girls' socks and it was known that I would give foot rubs to any girl who asked. In seventh and eighth grades I smelled a lot of socks.

At one point my parents found out and took me to counseling. After months of discussing ways to cure myself, I realized that I didn't want to change. I love socks. It doesn't hurt women or myself, so why should I change? So I guess the counseling did help me after all.

Viva: Were you shy or ashamed initially when you'd ask strippers to wear their socks onstage? You seem to have come out of your shell quite a bit in the few years I have known you.

SSG: At first I was very shy. I just watched the dancers (although I have a sock fetish, I am not blind to beautiful women!). Gradually I got to know a few of them and asked a couple of my favorites to take off their boots and dance in socks.

I guess it was at Dino's Club where everything 'took off.' I would come in around lunchtime and sit at the bar; the girls would sit on the stage and take off their shoes. They would spend the whole set putting their feet over the bar in front of my face. Over time, the feet started coming closer and then touching my face.

Enter Union Jacks and the beautiful goth girls and their wonderful table dance area. Table dances changed my life. The girls keep their clothes on and just sit back and put their feet in my face. The contact is amazing, the smell is awesome, and the women are great. They get to relax, keep their clothes on, and the ones who want it get paid to receive a foot massage.

Viva: Describe your favorite stinky sock encounter.

SSG: My favorite encounter? Hmm, well my favorite series of encounters was with a dancer named Kitty at Magic Gardens. She was the first dancer to stand on my chest in a club. God that was so hot. Kitty has great socks and a perfect body.

I remember looking up when she was first trampling me and she was biting her lip just staring at me with this sexy look. The red light from the table dance area was behind her head, her hair was glowing

red, her face was all shadow, and her eyes were staring into mine. She did everything right. She would push down with her feet to take the air from my lungs, then move her socked feet to my face so I had to breathe through them. Even now it turns me on thinking about it.

My best non-trample encounter was a couple of years ago with a girl from Union Jacks. She was a hard-core goth and did not have smelly socks, but she said she had a pair of tights with her that she wore all the time. She came out with a pair of black-and-white-striped pantyhose. They were pull-ups (over the crotch) that she wore daily as part of her non-stripper life.

OMG! The smell was so fucking perfect. It was amazingly strong. The smell I like is the smell of a woman's body. I do not like dirt, mud, or wet shoes. I like the smell of socks inside boots when a girl wears them a lot.

She just sat there smoking and grinding her feet into my face. She asked me about the fetish a little and then kinda shrugged and just let me play with her feet for the night.

VIVA: Does your wife know of your kinky pastime? Does she support it or indulge you with her own smelly socks?

SSG: My wife knows. When we first got married, I let her know that was a part of me that I was not ready to give up. I was making great money at work and had enough to spend and she did not mind.

She wears her socks for a week at a time. Socks are a big part of our sex life. She smells her own socks when she is cumming (she takes them off during sex and holds them to her face or my face). She is an amazing woman.

She also likes the sex when I come home. I never do anything sexual with the dancers. No kissing, no fondling, no nudity during dances. It is all just the socks, so that makes my wife much more comfortable.

VIVA: What is your ultimate smelly sock fantasy?

SSG: Actually my wife and I have been talking about this. My fantasy is one woman dominating another and making them smell her socks. The wife wants to try bondage and has no problem smelling another girl's socks.

The wife and I are talking about hiring a girl to participate with us. The woman we hire would keep her clothes on at all times; I would not touch her except to smell her socks. The wife would be tied up and the woman would dominate her with her feet. I would perform oral

on my wife and have sex with her while the woman shoves her socks in our faces. The wife also wants to try having a woman in panties sit on her face smothering her while I eat her out. She is getting into the breath play as well. Struggling to breathe through smelly socks while cumming is very intense.

VIVA: Lately you've been increasingly into asphyxiation. What is the turn-on? And again, are feet required?

SSG: Socks are always a part of my sexual activities, but limiting oxygen while being aroused is amazing. The trick for me is to limit the amount of breathing (through socks over the face, girl standing on chest, girl sitting on face). It's like doing 'rush' drugs. When a girl is on your chest pressing down and restricting your breathing for several minutes and she suddenly gets off, the oxygen hits your brain and it is amazing. Add a safe level of alcohol and the experience is even better; your inhibitions are gone, your dick is rock hard, and you just have to get home and fuck your wife for a couple of hours.

Let me clarify. DO NOT EVER CHOKE YOURSELF ALONE AT HOME. Everything I am talking about requires a safe, sane partner. Tying a towel around your neck while jerking off alone will get you hurt. Do some Internet searches before you ever try something new.

Indeed! Thank you, Smelly Sock Guy. Long may you prosper!

Personal Ads, Parts 1–4
January–April 2005

PART 1: LITTLE RED BOOK

I just got out my little red book the minute that you said goodbye… I went from A to Z. I took out all the pretty girls in town. They danced with me…
—Love, "Little Red Book"

According to my daddy and Arthur Lee from the band Love, a little red book is where you keep the names and numbers of the nicer

ladies you've encountered in case you hit a dry spell and Mommy leaves you or Love bites the dust. That way you've got at the ready a list of lays for rainy days. Well, if I had a little red book, each name would be followed by a lengthy list of why NOT to call the cad EVER AGAIN.

It's been said that I have bad taste in men. Perhaps. But I prefer to think that it's just a lack of quality choices.

My roommate in Brooklyn gets lots of visits from hot Portland women. He marvels at how they all complain about their uninspired or just plain uninterested sex partners. What is up with that? I blame the weather. Or the slacker religion we all serve. But I'm gonna hang up my old hang-ups and take some responsibility for these lackluster lovers. I'm gonna write my own Little Red Book and tell 'em—at the door—what I want, when I want it, and when to get lost.

The women's mag's advice gal says, "A lot of anger comes from women's odd expectation that men know what we want. They don't and they're not going to guess. It's really helpful if we tell them." But say you come home from the strip club and tell your dude, "Honey, I was giving a table dance at work today and the guy was saying how he'd love to chew gently on every inch of me, especially the small of my back and, uh, the backs of my knees. And, uh, it turned me on. Could you try that? No, the guy was not hot. No, I was not *into* him. No, I don't want to date him instead of you. Geez! I was just asking!"

My shrink says I have a problem with communication, and that ninety percent of relationships that fail fail as a result of poor communication. Well, not me; not anymore. My Little Red Book will "communicate" everything: sex positions, food allergies, hygiene advice, favorite restaurants, and whether I want a princess-cut or round brilliant diamond ring.

I'm sick of lovers, of hunting them, catching them, training them, and then slaughtering them. I want a partner. And this may prove to be my biggest problem yet. I'm not interested anymore in casual dating. I'm not interested in casual sex. I have enough friends, and when I really need a quick toss, I have a short list of fine specimens that are willing to do the deed. What I need now is a mate. So, here's the first page of my Little Red Book. If you want to read the second page, e-mail me

at viva@xmag.com with your resumé and maybe we can arrange a life partnership.

Dear Male Partner Prospect,

You must have a job. You must have a future beyond bartending and rock stardom. You must not be an alcoholic. You must rub feet. You must have a functioning cock. You must have a car so you can take me on hot dates. You must be an excellent kisser. You should read the New York Times *and, on occasion,* National Geographic. *You must want kids. You must love animals. You should be an inspired lover and able to play my body at least as well as you play your guitar. Better yet, you should be able to play my body as well as Jimi Hendrix played his guitar. You must love music and be versed in the history of rock. You must be open-minded, goofy, adventurous, and wise. You must be responsible, respectful, and adoring. You must be loyal, hardworking, and optimistic. You must take good care of yourself and of me. Hopefully you are also cute and manly enough to rock a sarong while feeding grapes to a goat. [See photo of Peter Beard, page 23.]*

Give it a try, girls! Put little boxes in front of each directive so you have a nifty checklist. Then you gotta follow through. Don't go out with a guy unless he's batting a .75 average in your Little Red Book. Then make peace with the fact that you'll never get laid again.

PART 2: OUTRUN THE COPS

Um...so my last column? The one wherein I listed what I wanted from a male partner and then solicited resumés? Well, it was clearly incomplete. I got many wonderful responses—well-written requests for coffee dates, caring critiques of my value system, concerned advice, and pats on the back, but what was obvious in the end was that this love nut is a lot harder to crack than I made it out to be.

Ultimately it was the Hottest Chick in Town who—in the dressing room—made evident the error of my ways.

"Oh, Viva! If they would just LIE and say, 'Honey, I just outran the

cops today.' Or something! They have to be BAAAAD. Or they have to lie."

My God, I thought, she's right. Then I thought about my shrink who repeatedly asks me to examine my fondness for dating criminals.

"I admire them," I say. "I feel they are at odds with a fundamentally fucked-up and unjust system, and I worship them for it."

Said shrink thinks I lack the capacity to read people, like the last guy I dated who was missing a handful of teeth and who tried harder to procure a doctor's note saying he was RETARDED than he ever did trying to get a decent job.

One of my applicants for partnership called foul on my whole list. He deconstructed every line to show that my mating requirements were merely the usual What-Every-Woman-Wants: a hot, rich guitar player who gives her head for hours. He said my list was "at best coded and incomplete and at worst utter bullshit." Well, duh.

In the end it's all star signs and love potions. Men are from Mars, women are from Venus. Or, as my darling Scorpio supplicant put it, riffing on Tom Arnold, "All women are crazy. All men are stupid." Or, as my Brooklyn roommate is wont to say, "Chemistry is so important to you girls."

Isn't chemistry important to guys? Obviously they are less discriminating and can fuck a cold cantaloupe and get off happily, but aren't certain cantaloupes more to their liking than others?

Every ostensibly "good" relationship I've bailed on, I've done so due to lack of chemistry. If I'm not totally turned on by you, sex feels sweaty, sticky, uncomfortable, and, ultimately, not unlike rape. Conversely, if I am into you—you ASSHOLE—you could hit me and, as the Phil Spector song goes, it would feel like a kiss.

So obviously there's a new list. A continuance. A second page.

Dear Male Partner Prospect,

You must be a criminal. You must not treat me too well or I will not respect you. You must push me up against the wall of the shower on occasion and stick your tongue down my throat. Most importantly, I must really and thoroughly enjoy this. Otherwise you are going to jail.

Goddamnit I don't know. A lot of this boils down to hero worship. I've got to respect and admire you in order to get hot for you and most of

you are so ugh! I've done a lot with my life. I've lived—alone—on four continents and in six states. I'm an athlete, an artist, and an intellectual. I play four instruments and speak five languages. I bathe frequently and I like to fuck. I have wonderful friendships with hot chicks, and I volunteer time and money to charitable causes. I've recorded seven albums, appeared in countless movies, documentaries, and music videos, and seen publication of my writing in national periodicals. Not to toot my own horn or anything, but it's getting harder and harder for you to impress me.

But then again how hard can it be? I'm a girl who's impressed by the bums on street corners. My last boyfriend didn't have a job or teeth! But in the end, I run with wolves and you simply have to keep up.

What you can bring to my life are the things I can't create on my own—that sweet easy feeling that everything is gonna be alright, that it's only life after all, that we're gonna rock out with our cocks out until they put us in the ground. And, on occasion, push me up against the wall of the shower, stick your tongue down my throat, and tell me you just outran the cops.

PART 3: GUITAR 101

I'm busy. I'm always always always busy busy busy. My mind is a dominatrix, and it doesn't let me fuck around. My body is the guitar in the corner, unplayed and gathering dust. It's well-made and sounds great, but you've got to pick it up and play it. With a little study and practice, it totally rocks. Here are some hints. Guitar 101.

First off, if I'm at home I'm either working or sleeping, and I pity the poor fool who tries to interrupt either. If you wanna fuck, get me out of the house. A bar, an art museum, the zoo, a rock show, out to dinner, the dog track—anywhere there are outside stimuli to take my mind off my internal chess game will do nicely. Walk around, hold my hand, maybe buy me a cocktail, and then tell me everything with a long dirty kiss. Squeeze my hip firmly as if to say "you ain't goin' nowhere," then steer me to a nearby closet or bathroom. Easy as pie. Initiating sex in the private sphere requires a bit more caution and skill.

Always approach me from behind. It's scarier that way, and I like the thrill. Don't approach me from the front. Face-to-face is an aggressive stance and I will turn into an argumentative bitch.

Pull me close to you, firmly, from behind, like the big strong man you are. Sure you already have a big strong hard-on, but don't beat me over the head with it, cuz I'll hit back. You've got big strong hands. Use them. And don't pussyfoot around. Be confident, yet subtle. Work on your Jedi mind tricks. The point you are trying to get across is "You are an insatiable vixen who's about to get fucked to within an inch of her life." Jedi mind tricks work extremely well.

Pet me a little. Stroke my hair; maybe grab it a bit too firmly at the back of my head. Nothing works like a little pain to snap me out of mental mode and into physical. Pull my hair even harder so that my head tilts back. Wedge two fingers between my teeth, opening my mouth just a tad. Kiss me long and slow. Be very deliberate. I am an insane chick, a frantic overachiever. I desperately want you to be the boss, but I will never ever say so.

Once you've got my attention, go for the jugular. My neck is among the top five places you should gently chew on (along with my hip bones, ears, spine from tip to tail, and the insides of my upper thighs). Bite my neck for a while, up and down and around to my collarbone. I saw a male lion do this to his girl in the Serengeti and I swear I wet my pants. "Oh, she's liking that!" purred my friend Kate, coaxing him on.

The neck is a very important erogenous zone. You'll get much further much faster by chewing on my neck than you will lapping at my labia or sucking on my tits. In fact, if you so much as sip on the latter, I'll probably punch you, you big fucking baby. My nipples are very sensitive and don't like to be manhandled AT ALL.

Back to my neck, which is (hopefully you're noticing) very, very close to my ears. Lean in and whisper, softly but firmly, "I am going to fuck the shit out of you." Follow that with a bit more nibbling and I'll be on the floor.

Once I'm on the floor, get my pants off. I've surrendered so you'll have to do this yourself. Belt, buttons, zipper. My legs are a couple of fucking clitorises, I swear, and no one pays any goddamn attention to them. Probably cuz by this point I'm insisting you take the plunge.

Don't. You're the boss! You've come this far, don't blow it. Don't let

me tell you what to do. If you give in to me I'll want you to cum in ten seconds (I cum in nine) so I can go back to work. Make me wait. I'll go nuts. The longer you stoke my fire, the hotter it'll be.

All this is really Boy Scouts stuff, but most of you seem to have forgotten it. Everyone could use a few remedial lovemaking classes. But then you have to do your homework. If you are going to play guitar like Jimi Hendrix, you need to practice a lot. Ideally you should practice every day.

PART 4: SURRENDER

Last night at the Shanghai Steakery, a middle-aged man rockin' a dirty blonde mullet and Captain Kangaroo glasses, dressed in a t-shirt that said ARMY on it and sporting a full-arm cast, bought me a drink. He needed change for video poker and the bar couldn't break a hundred without him buying something. So I got a pint glass of whiskey (the Steakery RULES) and thanked the gentleman profusely.

"You in the army?" I asked.

"Used to be. Late eighties to early nineties."

The guy was completely unanimated. His thin lips barely moved when he spoke.

"See anything interesting?"

"Nope. I was stationed here. I was a sniper."

"Ahhh. So if you had seen anything interesting, you wouldn't be able to tell me, huh."

"Nope."

He worked at a second-hand tire shop. A tire exploded and the shrapnel had torn a whole in his hand and ripped up the flesh on his arm. He was fresh out of the hospital. The Shanghai Steakery was his first stop.

"Sure am glad I'm single," he said, looking around, knocking over his beer in the process. On his left two elderly fags were making goo-goo eyes at each other. I was on a date. My date was wearing lots of eye makeup and had his hand down my pants. A busty sixty-something transvestite blushed as the pretty young bartender boy gave her quarters for the pool table.

"Huh. That's not something you hear every day. Why do you say that?" I asked him.

"Don't gotta answer to no one. I'm free to just go where the night takes me."

"Get to surf the chaos, right?"

"Yep."

Goddamn, I thought. Here he is. Another Angel of the Lord.

Viva, Thou Art Single For A Reason, And Thou Art LOVING EVERY MINUTE OF IT.

God, it's so weird when God speaks through mulleted blue-collar types at gay bars. My last three columns have been pitiful pipe dreams of a thirteen-year-old who suddenly finds she's of childbearing age. To recap: "I Want a Man," "I Want a Criminal," and "Here's How You Fuck Me." You probably expected this column to be a list of qualifications for sperm donors.

But you know what? I'm good solo. Real good. I love living alone, I get a ton done, and I get to see all my girlfriends. The reason I've been in a half-dozen failed relationships is not because of the boys I've dated—Drunk, Dick, Asshole, Loser, Liar, and Prick—it's because of me. I can't do relationships.

I turned my attention from the Angel of the Lord to my date. I really, really liked him. He said all the right things and touched all the right places, inside and out. How long before I fucked it up? Probably when he started wanting something I couldn't give: commitment.

I'll suck your cock 'til the cows come home, but the moment you need anything else, well, anything requiring me to give up surfing the chaos of life, I'll disappear. So long, sweetheart.

I'm trying to change. I do have cats. Two cats. They expect to see me every night and, after nearly nine years with them, I'm falling in line. I'm committed to them. I can do it. Commitment.

Could I commit to you, Sugarlips? So far you've really fuckin' hit it. Maybe if you're patient and you persevere, keep saying all the right things and touching all the right spots, if you read my last three columns and are really fucking lucky...

Nevermind.

Eighty-sixed from Union Jacks
May 2005

I got beat up by a stripper last month. Well, not really beat up, more assaulted. Long story short, she insists on thinking that I fucked her boyfriend.

This happened to me once before when I worked at Mary's Club. A girl I worked with—she said she was studying to be a nuclear physicist and I believed her—was dating an absolute cad I'll call Lucky.

Lucky frequently sat at my rack and was always asking for a date, my phone number, some pussy. And I always turned him down. Then one quiet day shift while I was reading Beth's *Economist* in the dressing room, all holy hell broke loose. Lucky, the bastard, had actually told his old lady he'd laid me. The nuclear physicist was pissed and threatening to detonate like an atom bomb.

The situation was so absurd I had to restrain my laughter. Instead I tried to hypnotize her.

"I did not fuck your boyfriend. I did not fuck your boyfriend. I'm in a long-term monogamous relationship. I did not fuck your boyfriend."

She threw a hairbrush at me or something and then left town to have the bastard's baby. But she never got over it. I had most definitely fucked her bastard boyfriend. Nothing I could say or do would convince her I hadn't.

My grandma told my mom told me that women are snakes in the grass and are not to be trusted. But for most of my time in this fair industry, I've been delighted by the sisterhood at the strip bars and the ho's-before-bro's ethos. I'll lay down my heart and soul for any lady in the dressing room. Anyone else, even my lovers, has a hard time getting me to cough up my e-mail address or phone number.

So this most recent guy I didn't fuck... Truth be told, he and I have barely gotten along at all since his last girlfriend slapped me at Dante's. But his latest lay got it in her head otherwise. So she wrote a slanderous article about me in a now defunct rival of *Exotic*'s which inferred that I (a) am a talentless writer, (b) am overweight, (c) have herpes, and (d) am fucking everyone's boyfriends. Then she quoted Anton LaVey, damning me to an eternity in hell for my wayward ways.

Girls I work with—the ho's-before-bro's girls—were incensed. They wanted blood. I've heard reports that the budding Satanist was threatened onstage and more. But I stayed out of the fray. It was, quite frankly, ridiculous. Plus, after twenty years of fucking it up, I've finally learned that it is indeed better to turn the other cheek and to forgive and forget.

Three months later, I stopped by a strip bar for an Irish coffee on my way to work. She happened to be dancing.

My young friend—who, as Goddess Severina pointed out, is so plain as to be almost unrecognizable—spotted me instantly. She accused me of coming in on her shifts to antagonize her. She was hysterical.

"Honey, you're so vain." I replied calmly. "I don't come in for you; I come in for a drink."

She threw a fit, threw my drink and purse across the room, then had me eighty-sixed. This was mildly upsetting. But it made for good times at the pish-posh restaurant I work at when I came in, feathers ruffled, and said, bewilderedly, "I just got beat up by a STRIPPER!"

Later in the week I phoned the club's owner to apologize for the incident and to determine whether I was indeed eighty-sixed. Yup, I was.

It's remarkable, I told him, for a strip-club owner to put a dancer's relationship drama before a customer's dollar.

"We have a policy here," he said. "Whenever a girl feels uncomfortable with a patron, we ask him to leave."

Holy shit! I thought. A ho's-before-bro's STRIP-CLUB OWNER! I wanna work there! But…I'm eighty-sixed.

Oh, well. I'll get my Irish coffee across the street. In the meantime, I'm printing up new t-shirts, just in time for summer, that say, "Jesus Christ, lady. I did NOT fuck your boyfriend." Get yours today at xmag.com!

(And by the way, if a guy I'm trysting with strays, I don't go after the bitch, bitch, I go after the hound.)

Katrina
October 2005

It's Halloween time again—a time to honor the dead, the darkness, and, most of all, chaos.

Last month was especially dark and chaotic. Much of it I spent glued to the Internet, watching the surreal circus our country became after Hurricane Katrina.

Though absolutely horrific and heartbreaking, there were moments of high comedy. I particularly loved watching the government wanks claim they didn't know there were thousands of people stranded in New Orleans. Watching the bloated Republican cartel try to pass off responsibility for bungled rescue operations was hilarious. And I thought it was pretty fucking funny when W. said the same exact meaningless bullshit he always says. But probably my favorite episode was the entire country's shock at the existence of millions of poor black Americans in the quaint tourist town of New Orleans. Who knew???

Suddenly there was the pressing question of what do we do with hundreds of thousands of homeless poor blacks? Where do we put them? Everybody wanted to help, but many cities (Portland, for instance) blanched at the idea of importing poor blacks into their neighborhoods. Cuz everyone knows that poor blacks steal televisions... (To which my well-off white girlfriend from New Orleans quipped, "You should all be so lucky. Those people are the most generous and wonderful people on Earth.")

Once upon a time I met some of the now-famous poor blacks of New Orleans. I'd just spent six months studying in Tanzania, the second poorest (black) nation in the world. Still, New Orleans—smack dab in the center of super-rich America—had the poorest poor blacks I had ever seen. Jesus Christ were they poor! I met one poor black kid on the banks of the Mississippi River. He was tap dancing for tourists with caps from jelly jars stuck into his flip-flops with rusty nails. Though the kid didn't speak English—only a pidgin patois—he and I hit it off enormously. I thought we were pals. I guess now he's stealing televisions and bottled water.

Race and class are the elephants in America's closet. It is remark-

able how easily we ignore them. Our society makes poor blacks poor in thought, word, and deed. Then when they are really and truly fucked and we are finally forced to take notice, we wring our hands and offer up platitudes while our leaders bluster through press conference after press conference in the vague hope that if we ignore the poor blacks for long enough, maybe they will just GO AWAY.

Two-thirds of New Orleans is black. One-third of New Orleans lives below the poverty line. Of the poor, eighty-four percent are black. The marvelous city of New Orleans has always been a city of marvelous poor blacks!

I would like our media to remember that even poor blacks have multifaceted lives that are full and rich in ways inconceivable to sheltered white folk. And goddamn if the poor blacks in New Orleans haven't always been a breed apart. They are a jubilant race, beautiful and tenacious. And if there is any hope of rebuilding the Big Easy, it's not the engineers and bureaucrats who will do it, it is the poor blacks.

Thanksgiving
November 2005

Maybe there was a problem with my upbringing; perhaps I was born under a bad sign.... But I have never been able to stomach the idea that a government should decide what I can and cannot say, can and cannot do.

When anyone tells me I can't say *fuck*, I am suddenly stricken with Tourette's and screaming, "Fuck, fuck, fuck!" If they tell me I can't masturbate onstage, I am overcome with the urge to strip with a vibrator up my ass.

Now, certain words and actions I like to steer clear of; as a matter of taste I prefer not to overuse the words *nigger*, *kyke*, and *boyfriend*. I resist the temptation to murder and rape not because anyone tells me to, but because I have nurtured a morality that senses these things are unkind. Still, if The Man tells me not to rape or murder or scream

"nigger Jew" or "Christian cunt," my natural disposition is to ask "Why the fuck not?"

I recently heard in the news the sad tale of a woman who was ordered off a plane for wearing a t-shirt that criticized the current presidential administration with the word *Fuck*. So now I have to find a shirt that says "Fuck You You Fucking Fuck" before I board my flight to Hawaii tomorrow morning. Some people call this speech offensive. I call it a speech un-impediment.

Although all Americans are entitled to the First Amendment's protections of "speech" and "expression," many states have ruled that certain types of speech and expression are too offensive or obscene to be permissible. In fact many states find boobs and vaginas obscene, in spite of the fact that nearly every woman on earth has 'em.

As far as I can tell, what these states are saying is that my body is offensive. And, after a cursory glance at any teen clothing store, one could surmise that these states find my body more offensive than a t-shirt that reads "Fuck You You Fucking Fuck."

Which is half the reason I live in Oregon. In Oregon my naked parts are viewed as "possibly distasteful to a large segment of society," but still entitled to protection and expression under the Oregon Constitution. Which is awesome.

I didn't fully understand just how awesome this was until I moved to NYC and had to slap a G-string on my stuff. Overnight my vagina and asshole were obscene, dangerous and a threat to polite society. And you better believe I fuckin' felt it! There is an implicit shame in requiring a woman to keep any part of her—brain or body—under wraps, whether it's a tit some kid is sucking on at a restaurant or a flash of gash at the corner strip club.

In Seattle, strippers were recently required to cover up, turn up the lights, and step four feet away from customers during table dances. This—to me—begs the question: if it is unseemly/obscene/illegal to be three feet and eleven inches from a customer, why is it suddenly okay to be one inch further away? And what if your pretty high heels and head are the full four feet away, but your well-endowed ass is six inches into the danger zone? Then what? The city shuts down the place and opens another Starbucks?

Here's what I find obscene, distasteful, and harmful to society:

Jessica Simpson, Western medicine, bad movies, not-free-range meat, President George W. Bush, and the Christian Right. Put a fuckin' G-string on those fuckers!

Ahem. Since it's Thanksgiving time, I'd like to close with some of that Christian bullshit I've been raving about. Thank you, God, for my friends, for strippers, for my beau and my brother; thank you for my cats, the Shins, and my health; thank you for Yves St. Laurent mascara, retarded dwarves, and Miranda July's *Me and You and Everyone We Know*. And thank you, sweet Jesus, for the Oregon Constitution and the Oregon Supreme Court, which last month decided two cases in favor of nude dancing. Amen.

What Color Panties Are You Wearing and How Long Have You Been Wearing Them?
Dedicated to the Cramps

LUX INTERIOR [THE CRAMPS]: I'm not wearing any panties.

IVY ROHRSCACH [THE CRAMPS]: Black; always G-string.

LEMMY KILMISTER [MOTÖRHEAD]: Green briefs for two days. Boxers are truly awful! I wouldn't be caught dead in 'em.

DUFF MCKAGAN [GUNS N' ROSES]: I'll never tell. [Under coercion...] I'm not wearing any panties.

DEZ CADENA [BLACK FLAG]: Checkered boxers...and they're like purplish brown...and they're...uh...what's that called? Flannel! And I've been wearing them for two days.

MISTRESS GEN [GENITORTURERS]: Oh, God! I ran out of clean panties four shows ago, so I'm not wearing any. I've given up on panties on this tour.

JEN GENOCIDE [THE VILES]: Vintage, black, skin-tight panties. I put 'em on today but I haven't washed 'em for a while. These have been through, like, four shows.

DAWN OF THE DEAD [THE VILES]: I myself am a fan of T-backs. Tonight they're black satin with a leopard spot on the side, and I've been

wearing them since this morning. I'll take 'em off tomorrow and wash 'em cuz I get really sloppy panties after a show.

CRISTINA MARTINEZ [BOSS HOG]: [Taking a peek] Ooo! I'm not wearing any!

KERRY KING [SLAYER]: Did I change shorts today? [He checks.] Nope, I didn't. Grey, two or three days...I almost changed today! I don't know why I didn't.

PEACHES: I'm not wearing any. I've given all mine away on this tour. And I tried on pants yesterday at, I'm glad to say, the Gap.

BRIAN CHASE [THE YEAH YEAH YEAHS]: I go commando.

ADAM BABY [EXPLODING HEARTS]: Black boxer briefs, but I'd take 'em off for you.

TERRY SIX [EXPLODING HEARTS]: None since noon.

KID CHIGNON [EXPLODING HEARTS]: Black briefs.

MATLOCK [EXPLODING HEARTS]: Yellow for twelve hours.

MARK ARM [MUDHONEY]: [Affecting an accent] Well, they're a tartan pattern, and I've been wearing them for about ten hours now. Boxers.

STEVE TURNER [MUDHONEY]: Mine are also tartan. What day is it? This would be day three. I am NOT down with the combo thing [boxer-briefs]. Dan [Peters] still does it, you know, the combo whatever...I roll with the man hammock myself.

WAYNE KRAMER [MC5]: Lime green boxers and they're brand new. I put them on fresh this morning.

RICHARD MELTZER [VOM]: Black, and fresh today cuz I took a shower. Yourself?

HANDSOME DICK MANITOBA [THE DICTATORS]: Black, two-button Calvin's. HDM DON'T WEAR NO PANTIES!

TOODY COLE [DEAD MOON]: White and probably three days. I'm lazy and I use whatever—plain old cotton shit, nothing fancy. I'm not a girl girl.

KEN GETHWAY [MONSTROUS]: Regular boxers—black. I change every day.

LED GETHWAY [MONSTROUS]: [Avoiding the question] I'm Led; I play guitar. Kenny plays bass and Alex plays drums. And we all write the songs equally and we're in a band called Monstrous.

ALEX GETHWAY [MONSTROUS]: Blue ripped-up...uh...boxers...for ten years.

APOCRYPHA

December 2005 was my last issue of Exotic, *after which I freelanced for various periodicals while I focused on writing* Magic Gardens. *Two and a half years later, at age thirty-four, I was diagnosed with breast cancer. I wrote about my experience for* Portland Monthly, *which is reprinted here with special permission from the magazine.*

The Last Days of My Left Breast
March 2009

You should see my tits. Right now. They're quite impressive.

My right breast is an A-cup, a small, soft mound of flesh with a pert, pink nipple the size of a half-dollar. It's familiar, and looks much like it does in the countless photos and movies it's appeared in over the past couple of decades. It's not gonna stop traffic or anything, but it looks good. My left breast, on the other hand, maybe could stop traffic. It's straight out of a horror film—the size of a cantaloupe and just as hard, skin stretched taut, with a long black trail of stitches on the side. The nipple is a psychedelic swirl of pinks and deep purples. The center of it is black. *Black.* Still, I have to admire the progress. The wound has closed up, and, apart from the nipple, the skin color is approaching normal. A week ago my breast was a giant yellow, green, and purple bruise, ringed with subcutaneous plastic tubing attached to a drain bulb.

A week before that it looked much like its neighbor. My breast went to band practice to prepare for the Coco Cobra and the Killers reunion show, swam laps at Cascade Athletic Club, and worked way too hard juggling three jobs: stripping, bartending, and writing. It also took the

stage at Mary's Club one last time after twelve years—naked and proud throughout the strains of its swan song, the Stones' "Doncha Bother Me," rising and falling with thousands of breaths, and stoically covering for an aching, grieving heart. Then, on September 26, 2008, it submitted itself to the surgeon's knife to remove some tiny bits of cancer that had taken up residence.

The following is a travelogue of my journey through the wilds of breast cancer, and an ode to a body part that always more than did its job.

Thanks for the memories.

RIP.

Lump

Like most women, my entrée into the world of breast cancer started with a lump, found by my erstwhile beau during one of his routine "breast exams." The lump wasn't exactly difficult to discover: my breasts aren't much more than lumps, and a lump on a lump is, well, noticeable. Still, if not for him, I wouldn't have caught that gumdrop-size nodule over my heart for a good while longer. And cancer, as I've learned, really wrecks the place the longer it's in town.

Next I did what any stripper would do and told the girls at the office. Strip-club dressing rooms can be potent nuclei of female power and amazing sources of information—like covens or sewing circles. The strippers said lumps are common. They also insisted that I see a doctor.

Down at Old Town Clinic, my nurse practitioner, Dana Mozer, fondled me thoroughly. After examining every centimeter of my breast, she pronounced that my lump wasn't of much concern. Good lumps, like mine, move around; bad lumps stay stubbornly in place. Good lumps also grow and shrink, sometimes depending on caffeine intake, so we scheduled another appointment and I cut down on coffee—but two weeks later my lump was the same size. Although I was only thirty-three and have no family history of cancer—breast or otherwise—she booked me for my first mammogram.

If this is virgin territory for y'all, a mammogram involves flattening one's breast like a pancake between two hard plastic plates and taking

images. My small breasts proved difficult for the pancake-maker to get hold of, so the scans had to be repeated several times. Next, I had an ultrasound, which can uncover abnormalities not revealed by the mammogram. Both the mammographer and the ultrasound tech thought my breasts looked perfectly normal. I was hugely relieved...until the overseeing doc came in, held up my images, and brusquely pointed out a handful of tiny white dots—calcifications that were suspicious for cancer. She ordered a biopsy.

I pursed my lips and tried to hide my irritation. So far the doctor appointments were primarily an inconvenience, but a biopsy? That meant losing a chunk of my breast! It also meant there might be something seriously wrong with me, yet all I could think of was what it meant for my mortgage. How would I strip with a chunk missing from my breast? How big would this chunk be? Would I be able to hide it with Dermablend?

The Wait

"The Wait" is my favorite Pretenders song ever. Its punk verve has steered me through many a rough patch. But the forty-eight hours between my biopsy and "The Phone Call" (another great Pretenders song) were a symphony of escalating anxiety.

I tried hard to put the questions out of my mind, and to convince myself that the tiny white dots were nothing out of the ordinary. Fortunately my mom was coming for her first visit in ten years, to see the house that my brother and I had bought and shared, so I distracted myself by frantically preparing for her arrival. I hadn't mentioned a word of my breast adventures to my parents. I figured if I did have cancer, I'd spare them the agony and tell them at Christmas, when (hopefully) I was on the mend. If I didn't have cancer, why worry them with the possibility that I did?

By Friday, my results were overdue, and I was quietly losing it. I left a message with my nurse practitioner, then headed to my bartending shift at East End, where ten friends coincidentally appeared on a whim to say hello (a clear sign that something bad was about to happen). I

was busy slinging drinks when the doc's office left a message. I stepped outside to check it.

The Wentworth Chevrolet building was wonderfully bright and angular in the late August sun. The building had probably been there a hundred years. I took refuge in its shadow and prayed to it that our circumstances would not change—it would continue to be its old self and I'd remain the healthy bartender across the street—and that my voice mail would contain nothing but good news.

"Hello, Viva. Your appointment with the surgeon is at 10 AM next Friday."

My stomach sank and my hands started to shake. There was only one reason to see a surgeon: to get something cut. I frantically dialed my nurse practitioner, hoping to reach her before her weekend started. When I got her on the line, her voice held so much sorrow and empathy that I knew I was in trouble. Ductal carcinoma in situ Stage Zero, she said, and that she was sorry.

I walked back into the bar, told my friends I had cancer, then tried to hold it together while they fell apart. Somehow I made it through my shift. I drove home to my brother and mom—fresh off the plane from Minnesota—and chitchatted with them till they went to bed. Then I retreated to my back porch and, finally, wept.

Surgeon's Girl

I'm an optimist. I believed that whatever cancer had set up camp in my body could be easily eradicated with a little knife-and-putty action, much like getting a cavity filled. It turned out I was wrong. Thank God I had my friend Trina with me when the verdict came down.

Trina is a fiery, perpetually smiling redhead who will do anything for her friends. Diagnosed with Stage 2B breast cancer in 2007—at age thirty-three and less than a year after giving birth for the first time—she'd been through a double mastectomy, chemo, radiation, and the attendant psychological vicissitudes. She took the morning off of work to drive me to my appointment.

In the surgeon's waiting room at Legacy Good Samaritan Hospital,

I picked through the available literature. Everything was pink and addressed to "survivors."

I already hated the language surrounding cancer. It was the language of war: "battle," "fight," "survivor." Honestly, I didn't feel up for it. I was exhausted from overwork, nursing a broken heart, and literally world-weary after two decades of living with depression. What if I didn't want to fight? What if I didn't want to join the survivor clique?

"Do you call yourself a survivor?" I asked Trina.

"Fuck yeah I do! During much of chemo, it was all I could do to get through the day," she said. "I lost my hair, both breasts, I have crazy scars. Hell yeah, I'm a survivor."

A chipper young assistant led us to an examination room. She was so sunshiny and lovely that when she told me she had had exactly what I did—DCIS Stage Zero—and had gotten a double mastectomy, I didn't succumb to shock. After complete breast reconstruction, she was clearly pleased with the results. "No more mammograms, I don't have to worry about a recurrence, and although I wasn't unhappy with my thirty-five-year-old breasts, my new breasts look like they're twenty years old," she gushed. "And they'll look that way forever!" It was difficult for me to share her enthusiasm.

Judging by the online research I'd done, my surgeon, Dr. Nathalie Johnson, was one of the best breast surgeons in the Northwest and had received the proverbial Golden Boob Award at every breast cancer banquet and function. When she walked into the exam room, she exuded warmth and strength. She was also gorgeous, her dark brown hair graying slightly at the temples, her skin golden-brown, her smile huge. I immediately felt that I could trust her, and that I would do whatever she said.

Until she said: "Double mastectomy. That's the treatment I recommend for women under thirty-five."

I felt my eyes well up. Even after the assistant's preamble, *I had not expected to hear the word mastectomy.* It was a huge blow, not necessarily because it meant losing my breasts, but because it suddenly put childbearing—something I'd always dreamed of but that wasn't quite on the radar—front and center.

"What about nursing?" I asked feebly.

"Many women who *haven't* had mastectomies are unable to nurse,"

offered the assistant. "Just convince yourself that you're one of them and make peace with that." Trina and Dr. Johnson agreed; both confessed they'd had incredible difficulty nursing.

We reconvened in a conference room to discuss my options. I was lucky to *have* options—the cancer had been caught early—but that didn't make the decisions any easier. The assistant gave me the phone number of a gal my age who'd recently undergone a mastectomy and reconstruction, and for the first of many times I heard the words: "She's like you—she's single."

Yes, I was single. Trina was wonderful, but she was going home after my appointment to her princely husband and beautiful children. I would be sleeping alone. Probably forever, now that I was scheduled, in two weeks, to lose both of my breasts.

Bearing Bad News

I didn't want to tell anyone I had cancer. It felt like a personal failing, and I didn't want anyone to think that I was weak, vulnerable. I didn't want the role of the "sick person," or for people to treat me any differently than they had. But now that I was going to have to take months off of work and undergo major surgery, the time had come to fess up.

For this I primarily relied on text messaging: "Bad news. Got a touch of the cancer. Double mastectomy in two weeks! Unbelievable."

I was inundated with phone calls. My friends were furious, unbelieving, devastated. Instead of them comforting me, I had to comfort *them*, explaining over and over the details of the diagnosis and the reason for the aggressive treatment plan. Every single person considered a double mastectomy barbaric. In my doctor's defense, I quoted statistics, and with each conversation my reality became more real, and I more at peace with it. By the time I went to my bartending shift, I was able to laugh cynically at my new joke: "Did you hear I'm getting a boob job? And a tattoo!"

Anyone who knew me was shocked. I'd been a stripper for twelve years, but apart from a few hard-earned scars, my body had looked the same since puberty. I'd seen a lot of great boob jobs in my line of work,

but I never, ever wanted one. Ditto tattoos. My shtick on the strip stage was all about sincerity, and to me that meant baring the all-nude real me. Not to mention I'd always been a tomboy and an athlete, and I liked my barely-there tits. I was the last person who'd replace her breast tissue with gelatinous pads of silicone.

"You?!? Fake boobs? Why?"

"Well, it's free! My insurance is paying for it. Cuz...I have cancer!"

I thought my joke was really funny. Whatever patron I happened to be talking to would take a sip of whiskey and try to discern whether I was serious. And I'd blather on about my tattoo. Part of the reconstruction involved getting tattoos of nipples where my nipples had been. I thought that if insurance planned to pick up the tab for a tattoo, I might as well get something cool, like maybe the Ramones crest—the one with the eagle holding a baseball bat—or maybe the name of my other ex-boyfriend, Dickhead, in script over my heart.

During my downtime at the bar, I took a mental survey of myself. People clearly expected me to be more upset. I wasn't. It sucked to have cancer, to be sure, but I didn't feel depressed or even sad or angry. In fact, I felt more grounded than I had in a while, probably because there was something to focus my angst on, and, for once, a clear plan for my immediate future. Although I'd just begun my interaction with it, cancer seemed much easier than heartbreak or depression. Even the idea of being invaded by something that wanted to kill me lent a fresh perspective on life, and considerable relief.

One night at East End, I took out a pen, drew a line graph, and labeled it "Continuum of Things That Suck." Heartbreak fell at the far end of suckiness, as did the death of a pet. Cancer was certainly worse than flying, or middle school, perhaps even worse than a friend's betrayal. But I really believed heartbreak sucked the most. Or...maybe war. No! *Urban sprawl.* Urban sprawl was without a doubt the most corrosive thing I could think of, a constant source of grief and hopelessness. Cancer wasn't nearly that bad; in fact, it fell more towards Stuff That Doesn't Suck Quite So Much.

Three of my best girlfriends—the Stripper Mom, the Artist, and the Schoolteacher—interrupted my reverie. My diagnosis baffled them as much as it did me. They'd come to East End to get the details over a palliative cocktail.

"How will you nurse?!? Do you know how important colostrum is for the baby? And the mother!" screeched the childless but well-meaning Schoolteacher. I wanted to punch her.

"Oh, God. Nursing's not that big a deal," said the Stripper Mom. "But Viva, how are you going to survive? How long do you have to take off work? Do you have insurance? God… We need to marry rich! Now!"

Taking a drag off her cigarette, the Artist said, "Haven't I always said you'd make an excellent trophy wife?"

I felt like I was watching a Greek tragedy of my life, with my gal pals as chorus, voicing my three biggest fears:

I wouldn't be able to nurse my theoretical children.

Although I had insurance, I had no extra cash to sustain me for the three months I would have to miss work. And my stripping career was, in all likelihood, over.

I would make an excellent trophy wife. Or would have, until cancer butchered my chest and did God-knows-what to my insides. I figured I'd never date again.

Rebel! And Research

As the shock of my diagnosis wore off, fears and doubts began to surface, along with a million questions. Did I really have to get a double mastectomy? Did I have to do anything at all? If I did get the surgery, how would I cover my bills? And could my rock band still play a show on Halloween?

Also, why did I get cancer at thirty-three? It didn't make sense. I was always very solicitous about my health—I ran, swam, got regular acupuncture, had been nearly vegan for two decades. Yes, I worked in smoky bars, but only ten to fifteen hours a week. I never smoked. I drank, but rarely to excess. The culprit had to be stress. Or…

Friends chimed in with all sorts of unhelpful statistics. For instance, women who work nights evidently are more likely to develop breast cancer than women who work days. Another stat you won't see widely advertised: women living in the Pacific Northwest have some of the highest breast cancer rates in the nation, which some experts attribute

to lack of sunlight. One friend blamed my cancer on the terrible sunburn I'd suffered after my one ill-advised tanning-bed experience. Another friend blamed my ex: "The cancer is right over your heart. Your poor heart's been through hell the last few years. That has to have something to do with it."

My next move was to rebel. Who were these doctors, and why were they plotting against me? My cancer was *Stage Zero*. Zero in my book meant "nothing." What if I did nothing? The more I thought about it, the more I fell in love with that option. I could keep my breasts, keep a close eye on the rogue cells within them, and start meditating regularly. Some people call this "denial." I, however, just decided I needed a second opinion.

Soon I had an extensive list of naturopaths, acupuncturists, and breast cancer "survivors" to consult. I spent hours online, gathering information. I maxed out the minutes on my phone plan. I read all the breast cancer bibles, drank tumor-fighting potions (baking soda and maple syrup, anyone?), researched juicers (to get started on the recommended raw food diet), and signed up for breast cancer yoga, acupuncture, and even a cancer writing group. I talked to every breast cancer survivor I could, met them for drinks, and groped their reconstructed boobies in the dark bathrooms of hipster bars. I faxed my pathology report to doctor friends around the country. Without exception, every healer—whether hippie, holistic, occult, or orthodox—insisted I get the cancerous tissue surgically removed. Immediately.

Yet as the surgery date loomed, I panicked. I canceled my surgery and instead scheduled another consultation with Dr. Johnson.

For emotional support, I dragged my brother along. We found Dr. Johnson in surgical scrubs, presumably ready for a day of removing breasts, two of which should have been mine. She calmly addressed every doubt, fear, and question I had, including my fantasy of doing nothing. But she was much more stern with me than she'd been at our first meeting. We reviewed my mammogram. The first time I saw it, the white dots had looked so harmless; now, having spent two weeks in cancer boot camp, they looked much more sinister, and more numerous than I remembered. According to Dr. Johnson, I needed them out of there, ASAP. I blinked back tears, knowing deep down that she was right.

Later that day, I e-mailed my father. It killed me to write it—the

news would break my dad's heart. I felt like a complete and total failure. We were a family of health nuts and athletes. No one had cancer. No one except me.

Thankfully, I had a shift at Mary's that afternoon. Of all the people I knew, I most wanted to be with my dancer family. They were generous and empathetic. They knew what it meant to rely on your body to make a living, and also the implicit terror in having that body fail you.

The annual Komen Portland Race for the Cure was coming up. The huge sign-up sheet that had appeared in the Mary's Club dressing room was covered with names—girls who would walk, along with the names of all the people they'd lost to breast cancer.

On the morning of the race, a group of us gathered outside Mary's. Eight in the morning is *very early* for strippers. But there we were, bundled against the chilly fall rain. We ambled down to the waterfront as a group. Forty thousand people were expected to attend, and as I waded through the crush of balloons, hats, head scarves, and wigs, I quickly became overwhelmed.

I spotted three cowboys in Carhartt work jackets and boots—tall, strong, handsome men, bent with grief. They carried a small sign with a name and photo on it—the older gent's wife and the younger ones' mother, I imagined. I choked up at the sight of them.

In five days, I was losing my breast. The Race for the Cure was the last place I wanted to be.

"I have a grand idea," I whispered to my two best pals. "Let's drink for the cure instead."

We marched with the throng down SW Broadway, past Mary's Club, then veered right into the front door of Embers. A fabulous bartender welcomed us warmly, poured us strong Irish coffees, and offered biting fashion critiques as the parade of pink surged solemnly by. Halfway into my whiskey coffee, I felt significantly better. We agreed to make Drink for the Cure an annual tradition.

The next four days were a blur. I met with my publisher regarding my book, due out in August. My band, Coco Cobra and the Killers, practiced one more time, in the hopes that I'd be back for our Halloween show at East End. I sat for a photo shoot, and, with my beloved writing group, planted hundreds of spring bulbs in my front yard. Clearly, life would go on after surgery. I just wasn't quite sure what it was going to look like.

During this time, my plastic surgeon, Bruce Webber, and I dis-

cussed what many people had recommended all along: take only the cancerous breast and leave the other one alone.

In retrospect, it's strange that I hadn't considered this option more seriously. I'd been so buried in information, processing the opinions of a dozen different doctors, that I saw my choices as all (double mastectomy) or nothing. Thank God for Dr. Webber. I loved the way he talked to me: no-nonsense and not patronizing in the least. I trusted him. And with his advice and approval, I arrived at my decision. The relief that accompanied it was intoxicating. I could finally let go of all the chaos, grief, and fear. I would lose a breast, but I would keep my sanity.

Party of the Century

And so, on September 26, I underwent a unilateral mastectomy. Dr. Johnson removed my left breast along with several lymph nodes for biopsy; Dr. Webber put in a tissue expander to start the reconstruction process, pumped it up with saline, and stitched me back together.

Because of the extent of the calcifications in my left breast, there was some worry that my cancer might have been invasive. After surgery, when I briefly came to, the first words I heard were that my lymph nodes were clean. The doctors also told me that my nipple had been salvaged, which I had no idea was even possible. I fell back asleep, hugely relieved. The next time I woke, I was in the midst of a party.

My mom had flown in, as had my buddy from New York. The Schoolteacher took the day off, and my brother stood by to do my bidding and send text updates to anyone who cared.

A lot of people cared. They gathered around me in my hospital room, drinking wine and watching the presidential debates, keeping me company as I came out of the anesthesia. By the next afternoon, the party had outgrown my hospital room and I was more than ready for a change of scenery. As soon as the nurse unhooked my IV, I was out the door. The Schoolteacher picked me up in her '61 baby-blue Porsche, and we rode to my house in style.

Someone had thoroughly scoured the place during my brief furlough; there were flowers everywhere, and my dog had been farmed

out (I was on strict orders not to walk—even around the block—for two weeks). Guests started arriving almost immediately, loaded with more flowers, groceries, books, and DVDs. My mom started an enormous pot of chicken soup while my ersatz mom, Vicki Keller, the owner of Mary's Club, critiqued the recipe. Bottle after bottle of wine was opened and consumed (not by me) while I lounged on the daybed like Cleopatra, basking in all the love and attention.

The party held steady for two weeks. People I didn't even know showed up with casseroles and stews, while long-lost acquaintances resurfaced with stories and babies to brighten my convalescence. I'd never recommend cancer to anyone, but I have to say that the weeks following my surgery are among the most treasured in my life.

Every day held little triumphs. Although most of the post-mastectomy tales I'd heard saw the patient laid up for a week, unable to so much as wrangle pajama pants, I insisted on avoiding loungewear. I was overjoyed when I found a dress I could slip over my extensive bandages (one gal pal said I looked like I'd been dressed by Azzedine Alaïa), and ecstatic when I discovered I could cautiously pull on a pair of jeans with one arm, and button the fly. Having my hair washed felt like a huge achievement, as did taking my first shower. Trina came over to help me with the latter, and together we unwrapped my new body part.

I couldn't look. But when Trina gasped and said it looked great, I peeked. There indeed was a breast. A black-and-blue and scabbed and swollen breast, but a breast all the same.

Motorcycles, Monks, and Money

That was supposed to be the end of the story. My mastectomy was supposed to have "cured" me. And I was planning, after a couple of months, to never think about breast cancer again. Unfortunately, things didn't quite work out that way.

The dissection of my breast tissue uncovered a tiny tumor that was highly aggressive—and that raised the possibility of lymphovascular invasion. In lay terms: although my lymph nodes were clean, cancer cells *may have* escaped the breast ducts into the bloodstream, where

they could travel anywhere in my body, most ominously to my bones, lungs, or liver.

The words "may have" caused me considerable consternation. For the first time, I was assigned an oncologist, and then a second, and then a third. The statistics were in my favor: it was eighty to ninety percent likely that the surgery had "cured" me, but if the cancer was on the loose and invaded my bones, lungs, or liver, it almost assuredly would be fatal. Although chemotherapy reduced my already slim odds of recurrence by only thirty percent, two of three oncologists recommended it, as did every naturopath, acupuncturist, and friend.

Once again I was faced with an agonizing decision—whether putting my body through chemo was worth such a slight reduction in risk. And again, the irony of my situation bemused me. I was lucky: I had options. By the time many women discover their cancer, their decisions are made. I could *choose* whether or not to have chemo. Still, for me, the decisions were the hardest part; decisions didn't feel like much of a luxury.

After four weeks of considering various treatments and assembling professional opinions, I was a wreck. If I hadn't felt like fighting for my life before, now I felt less like it. Usually when I'm that low, climbing on the back of a motorcycle is the only remedy. Although the plastic surgeon forbade such activity for two months post-surgery, I felt the benefits outweighed the risks. One glorious fall day I cruised around the West Hills on an old Honda, holding tight with my good arm to a Tennessee stud. For a couple of precious hours I felt like myself again, and the positive effects lingered a full two days.

Protocol required that I begin a course of treatment within three months of surgery. As time ticked away, I came more undone. I cried without provocation, my mind close to meltdown. The money thing became far more distressing as my illness threatened to command more of my future. I didn't know when I'd go back to work and had no idea how I would pay my bills. Without my friends, I would have been lost. They fed me, entertained me, and every time I got down to my last six bucks, some hero swooped in with a tank of gas, a bag of groceries, a free massage, a stack of hundreds.

Finally, perhaps hearing the distress in my voice, my biggest hero of all set his own rescue plan in motion. For years, my dad, a Lutheran

minister, had been prodding me to visit a monastery, promising that the silence and prayer would center and ground me. Convinced I needed sun with my silence, Dad insisted I take a trip south and booked me for a stay at the Monastery of Christ in the Desert in the Chama Canyon, just north of the tiny town of Abiquiú, New Mexico.

Which is how I found myself breaking bread with twenty Benedictine monks for a full week last November. I prayed and meditated and chanted and hiked in the desert. Slowly, I came back to myself. The tears dried up after the first few days, and I felt my soul start to return to its center. By the end of my stay, my smirk was back in place. During a silent lunch, I laughed out loud in spite of myself when the thought crossed my mind that I'd been in a similar situation countless times: a woman alone in a room full of men—but in the past I was almost always naked.

I came home from New Mexico happy and calm, and I met my oncologist, Dr. Bruce Dana, with a clear head and an open heart. I realized that, contrary to my alleged lack of fight, I had been fighting since Day One of my diagnosis. I was fighting loss, fighting change, fighting reality. And though I finally admitted life was worth fighting for, perhaps fighting wasn't actually the best way to handle things. Once I relaxed, the decision came: I would do chemo.

Sex, Drugs & Rock 'n' Roll

Healing is a process, both mental and physical. My body and my mind have had to stretch and grow in ways I wouldn't have thought possible pre-cancer. We've got a long way to go, but I'm confident that by summer I'll be rockin' a lovely new rack. And I'm looking forward to the punk possibilities of post-chemo hairstyles. Hopefully my mind will rebound in like fashion (if not, there are always those monks in New Mexico).

Already my left breast has stretched to accommodate two giant injections of saline. To me it looks huge, especially next to my A-cup right breast, but that didn't stop me from flaunting them both in a fishnet shirt at the Coco Cobra and the Killers show on Halloween. After

chemo, both breasts will undergo another surgery: the expander pouch in the left breast will be swapped for a silicone implant, and my right breast will be augmented to match. Although it's nothing I ever aspired to, for the first time in my life I'll have a proper pinup body.

I'll be seriously into pharmaceuticals for quite a while. After chemo, I'll start a five-year course of tamoxifen and a year of weekly injections of Herceptin, a designer drug that, at eight to ten thousand dollars a shot, will make me the Gal with the Golden Arm. I'd much rather be planning a sabbatical in New York City or a pregnancy, but for now, those things have been shelved. I'll be in Portland for the foreseeable future, basking in the love of my friends, playing music, and promoting my book while comforting gals newly diagnosed with breast cancer and letting them feel me up in dark corners of hipster bars.

And maybe, just maybe, I'll do a few cameo appearances on the stages of the downtown strip joints I have loved so well, slinking around in the buff to the Rolling Stones, preaching that all bodies, no matter what strange adventures they've been on, are beautiful.

The following is reprinted with special permission from Nerve.com.

Grindhouse Review
May 2007

"I loved the Tarantino movie, but the zombie flick? Gag me!"

Matilda's wicked tongue is sucking the salt off her first Bloody Mary of the day. She's a cannonball run—a pistol-hot stripper with a tattoo of Mata Hari, guns blazing, between her A-cup tits. At twenty-two, she's thrown up more Jägermeister than most frat boys have thrown back. I call her Tilly the Hun. She picked me up from a nightmarish afternoon shift at Mary's Club—"Rose City's First Topless"—and now we're taking a break from shopping at an Old Town boîte. Another couple hours and she'll be a raging maniac, but this early she's lucid enough to engage in conversation.

"Are you kidding me? The Rodriguez film kicked ass! It was a pitch-perfect drive-in flick. The Tarantino movie put me to sleep. It was retarded. Actually, I really shouldn't proffer my opinion, considering I did actually sleep through most of it. Not even Kurt Russell could snap me out of my stupor."

I really love Kurt Russell. He's been my hero ever since *Big Trouble in Little China*. On occasion I tell the boys my name is Snake Plissken.

"Ewwww! You like Kurt Russell? Gross! He's so customer."

Matilda considers "customer" to be the most deadly in her arsenal of insults. She'd sooner eat her audience for dinner than take their ones, fives, and twenties.

"IN SPITE of Kurt Russell, the Tarantino was far supreme. I love how he loves women."

"What? You mean the half hour of idiotic babble at the outset indicated a love of women? If anything its mild stupidity was insulting."

"Well, what about that *stripper* in the other one? She was AW-FUL."

"Rose McGowan? I loved her! Why does nobody else love her? I thought she did a fine job."

"She looked like someone trying to be a stripper, like someone told her what to do but she had no real idea. Like a *new* girl."

"I thought she was hot. Old-fashioned hot, like Honey Owens and Lenny Bruce. I loved that she looked straight into the camera."

"VIVA! You CANNOT tell me someone would pay to see her naked!"

"Bullshit! God, Matilda, you're such a ballbuster. I'll take a stripper sequence over a car chase any day. Even those lackluster strippers in *The Sopranos*. Even Demi Moore in *Striptease* or Courtney Love looking like she's taking a shit in *People vs. Larry Flynt*. I wouldn't care if it was Morgan fucking Fairchild pole dancing. Or even groady Jennifer Garner. I love strippers. Love 'em."

"Whatever."

"Whatever yourself."

Matilda twirls her auburn hair around her fair fingers. "Viva, loan me twenty bucks. I'm broke 'til my shift at Sassy's tomorrow night. Loan me thirty and I'll buy you a drink."

I give her a twenty, but it's the sucker sitting next to us who will buy the next round.

ABOUT THE AUTHOR

Whether naked on stage at a dive bar in Portland, Oregon, or walking the red carpet at the Cannes Film Festival, Viva Las Vegas brings passion to her performances and audiences to their feet.

Born and raised in the Midwest and a graduate of Williams College in Massachusetts, Viva has been a force in the arts for more than a decade, performing onstage as a singer, appearing in TV shows and more than a dozen films, and writing and interviewing for publications both local and national. Viva's atypical resume includes *Paranoid Park* and *First Kiss* (films by Gus Van Sant); *The Auteur* (a 2008 James Westby film); and articles in *The New York Times*, *Village Voice*, *Portland Monthly*, and *Exotic Magazine*. Her Portland band, Coco Cobra and the Killers, has recorded two albums, and she is frequently interviewed as a spokesperson for strippers—her compassionate voice always at the ready to rock polite society.

Viva's first book, *Magic Gardens: The Memoirs of Viva Las Vegas* released in the fall of 2009 (Dame Rocket Press) and explores her colorful meander from college to a career in stripping. The release also marked the one-year anniversary of her breast cancer diagnosis and treatment, part of which she chronicles in her award-winning article, "The Last Days of My Left Breast" (*Portland Monthly*, March 2009).